# Painting in Watercolor

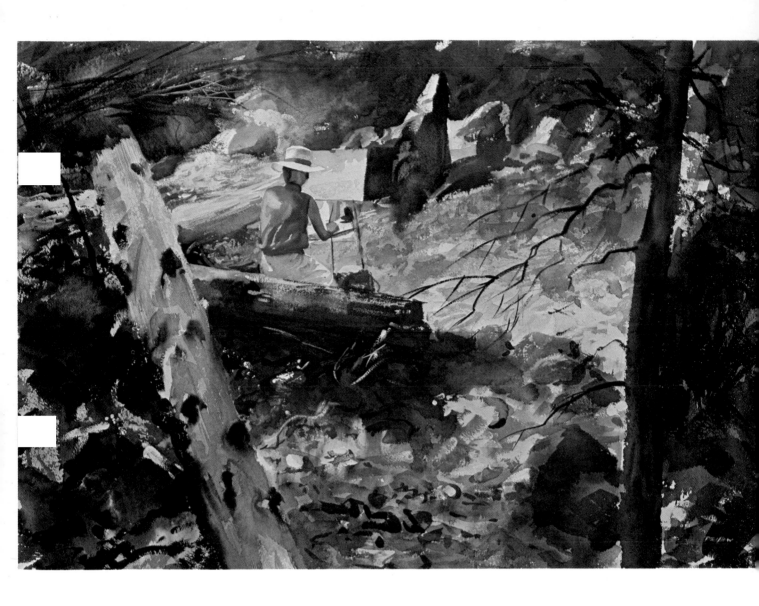

**Marianne Painting,** watercolor on paper, 20″ x 28″.

*Another Colorado subject. The young woman was a member of my workshop group. As a change from ghost towns, we painted the turbulent mountain streams. This is one of my favorites. In the clear atmosphere of Colorado's Rocky Mountains, the dappled sunlight on the rocks and on the bleached out fallen tree trunks sparkle with an almost blinding brilliance. Notice how the picture space was designed to make the figure the point of interest. The treetrunks lead the eye to the figure and the rectangles of canvas on the artist's easel almost becomes a target that keeps the eye there. The strong light, caught by the pointed rock near the top of the picture, helps move the viewer up and away from the artist's canvas. Without it, the bright rectangle, with its sharp edge, might have become an eye trap. Take the figure out of this picture and it would be difficult to judge the scale of the scene. My painting procedure was to work from light to dark. Except for maybe a half dozen light on dark spots of opaque, the picture was painted with transparent watercolor directly on the dry paper.*

# Painting in Watercolor
# by John C. Pellew
## N.A., A.W.S.

WATSON-GUPTILL PUBLICATIONS, NEW YORK

Published 1970 in New York by Watson-Guptill Publications,
a division of Billboard Publications, Inc.,
165 West 46 Street, New York, N.Y.

Manufactured in Japan.

ISBN 0-8230-3875-0

Library of Congress Catalog Card Number: 76-87322

First Printing, 1970
Second Printing, 1971

Edited by Donald Holden
Designed by James Craig
Composed in 12 point Bodoni Book by Atlantic Linotype Co., Inc.
Printed and bound in Japan by Toppan Printing Company, Ltd.

For Jon and Jennifer

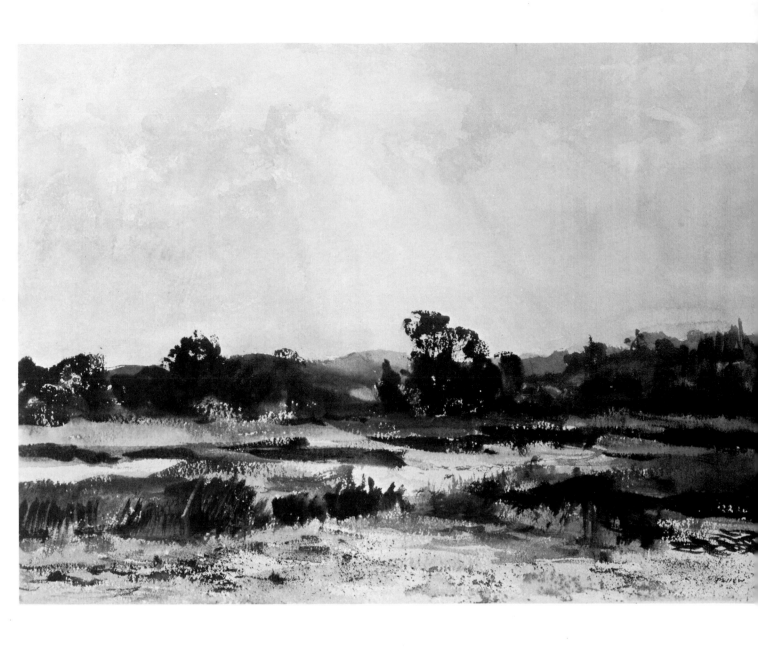

**Morning on the Marsh,** watercolor on paper, 21″ x 28″.

*Another salt marsh! Sorry about that, but I do like to paint them. To me, they're the perfect watercolor subject. Those along our eastern shores remind me of the Norfolk Broads, that low-lying marshy coastline of East Anglia in England. This one, however, is in Essex, Massachusetts. The day I painted it, I was with an artist friend who saw nothing to paint here and said so. He really meant it. For him to be happy, there should have been a picturesque barn somewhere just off center, and perhaps a glimpse of a white church steeple beyond the trees. Well, all right, if that's your cup of* *tea, go ahead and paint it; but don't tell me there's nothing to paint in the marshes. This full sheet was painted on the spot, using mostly a 1″ flat oxhair brush. It was painted looking into the light—a point of view I'm fond of. Note the dark silhouettes of the trees, beyond which are seen distant hills, quite cool in color. The trees are a mixture of raw sienna and thalo blue. The marsh grass is September color—yellow ochre in mixtures with raw and burnt sienna. When I'd finished, my friend strolled over and said, "Well I'll be damned; you made a picture out of nothing!"*

# Contents

# Introduction

For the past few years, interest in the British School of watercolorists of the late eighteenth and early nineteenth century has been slowly growing in the United States. Its acceleration, as far as the general art public is concerned, may be easily traced to the great Turner show mounted at the Museum of Modern Art in New York, in 1966—a show of such scope and depth, and revealing so many dazzling examples of this almost forgotten master, especially his effervescent impressions of light painted in watercolor and executed in modest scale, yet visually "larger than life," that visitors in impressive numbers came away amazed that an English academician—and not a Frenchman—was the newly "discovered" precursor of an important phase of modern art.

At about the same time, a loan collection of British watercolors, covering the century of 1750 to 1850, presenting 100 paintings by sixty-seven artists represented in the Victoria and Albert Museum, was circulated in eight major museums throughout the nation.

In this exhibition, all of the important British watercolorists were included, beginning with Paul Sandby, usually considered the "father" of the British Watercolor School, down to Walter Crane, born just before the close of this century span—in 1845. And in between these two painters, there were sterling works by such celebrated artists as Bonington, Boys, Constable, Cotman, Cox, DeWint, Francia, Girtin, Palmer, Prout, Towne, and Turner.

To most American watercolorists, the majority of these names may be unfamiliar, in spite of the exhibition just cited, and the recent publication of several books devoted to the life and work of Constable and Turner (two of these were issued by this publisher); but to the author of this book—John C. Pellew—they belong to the familiar household of his art and tradition.

For "Jack" (as he is generally called by all who know him) was born in Cornwall, England, and although he has lived in America for over forty years—following his art study abroad—his watercolor is a happy amalgam of his Celtic-Cornish birthright, and his consistent admiration and reflection of the English painters I have mentioned.

And like the best of them, his own art is invested with a sensitivity to atmosphere, with its diffused light like that found particularly in the Petworth

watercolors by Turner; by a similar love of country earth, expressed so brilliantly, and so long ago, by that short-lived genius, Thomas Girtin; and by a strong sense of structure, inspired by the examples of Constable and Bonington.

In addition to the standard he has set as a painter in watercolor (he paints equally well in oil), which has found favor with numerous juries over the years, resulting in the acquisition of a goodly number of prizes and awards, Jack Pellew has gained a notable record as a *teacher*. Only one who is well disciplined can be an effective instructor who is obliged to convey his constructive criticism by correspondence, yet he has been eminently successful in this field as a member of the teaching faculty of the Famous Artists School.

Also, he has conducted watercolor workshops and given painting demonstrations in various sections of our country, and we know of the approbation his talents have earned in these concentrated—and sometimes difficult— commissions.

It is because of these very reasons that this painter is admirably equipped to write a *good* book on the subject of watercolor—and one we are confident will be well received in spite of a large number of other manuals currently in print. For like the most meritorious of those by other authors, Jack Pellew does not "talk down" to his readers as though he knew more about the subject than anybody else, or claim that he can offer a perfect recipe for *any* reader who will follow *his* precepts, or even that by becoming a fair craftsman one will automatically turn into a *professional* artist. This is a status Jack Pellew feels—as I do—that the student must earn by fine performance, and that it is a real distinction when it is appropriately conferred by established artists, rather than by the next door neighbor.

But for all who "read" Jack Pellew and find, after putting into practice the experienced advice he has to offer, that they can achieve a solid *foundation* in the use of the watercolor medium, there still remains a *spirit* to covet. To extend one's own vision, the reader must find his own bedrock—a source like that which has inspired Jack Pellew—a constant reference to one's chosen peers, whose direction provides a highway that leads to a mountain higher than any can climb.

Norman Kent, N.A.

# Painting in Watercolor

**A Summer Garden, Rockport,** watercolor on paper, 10″ x 14″.

*Whenever the Pellews go to Rockport for a change of scene and to visit old friends, they stay at a cottage on Pleasant Street. This is a view of the garden from the cottage door. This is also a quarter sheet quickie, which accounts for its bold spontaneity. Why I never tighten up on a quarter sheet, but often do on a full sheet, is an exasperating mystery, but it happens. I think that this is the way an outdoor watercolor sketch should be painted: a series of bold washes, spots, and splashes; no attempt to paint individual leaves or blades of grass. If the character of a tree is captured in a simple statement, and painted in correct tonal value relationship to its surroundings, there's no need for finicky detail or for what I've called the "still life approach to nature." Students, study the edges here. There's not a hard, tight one to be seen. I painted the sky first, then put the trees right over it. For the greens, I used mixtures of cadmium yellow, yellow ochre, and raw sienna, with thalo blue. The dark trunks and branches were painted with burnt umber and a mixture of burnt umber and thalo blue.*

# The Wonderful World of Watercolor

Painting in watercolor can be a joy—or it can be as frustrating as the devil. It all depends on the approach of the individual. Children have a way with it. Adults often fail because they try to make watercolor do what would be better done in another medium. The very young have no inhibitions; grown-ups are loaded down with them. Let's say, right at the start, that watercolor is not for timid souls. Nothing worthwhile in watercolor was ever accomplished with timidity.

## Looking at the Masters

Later I shall deal with what I consider the correct approach to the study of this fascinating medium, but first I recommend that all students know something of its history. Today, many enthusiasts study only the works of their contemporaries. There's nothing wrong with looking at paintings in current exhibitions. See them whenever the opportunity presents itself. However, you shouldn't limit your knowledge of watercolor to today's top performers. There's much to be learned from the masters of the past.

Where does one start? Well, Albrecht Dürer (1471–1528) did some lovely landscapes and animal studies in the medium. Hans Holbein (1497–1543) tinted some of his pencil portraits with watercolor. These are very interesting, of course, but they have little to offer today's watercolor painter.

A good place to begin is with the English masters. I'll pass over the very early men who produced what seem to us to be tinted drawings. Let's look at a group of painters who broke away from the old school and were among the first to use the medium for itself alone, using it to paint their impressions of nature with bold washes of color, unconfined by outlines of any kind. I have a half dozen favorites and each of them has contributed something to my education.

## Turner (1775–1851)

The great master is Joseph Mallord William Turner, son of a London barber, born in the crowded alleys of Covent Garden Market. Turner was a genius who produced watercolors that are almost feats of magic. Those painted late in life are near abstractions. The student might look first at the works of the middle period, the topographical views of towns and harbors. Though they're technically astounding, they're no mere copies of nature. In fact, they sometimes just barely resemble the place named in the title. The first Turner I remember seeing was a reproduction shown in a dealer's window in my home town. I suppose I was about ten years old at the time. The picture was the beautiful St. Michael's Mount. I saw this picturesque landmark, near the town of Penzance in Cornwall, every day on my way to school. I grew up with it in my lap. I'm afraid Turner's picture made a poor impression on me. It wasn't much of a likeness. Thirty years had to go by before I could appreciate that fine work of art.

What should the student look for in Turner? Well, first study the middle period just to see what the greatest technician of the watercolor medium could do. Don't linger too long. You may get discouraged and quit. Give most of your attention to the pictures he painted late in life. These are the papers painted for himself alone and never exhibited in his lifetime. Study their simplicity, their great understatement.

I feel that we often try to say too much today. The exhibitions show too many oversize papers that have been scratched; scraped; covered with dark, muddy, opaque color; and overworked with drybrush. Sometimes the results are strongly dramatic, but most of them would have been better painted in oil. How do they compare with those small poems—in thin veils of color—by the old magician? I'm sorry I brought it up. There's no comparison.

Some museum people have tried to label Turner the forerunner of modern abstract art. Sheer nonsense. True, the late paintings were almost abstract, but the old man wasn't trying to paint abstractions. He was concerned with painting light and atmosphere—the very qualities which nonrepresentational painters have claimed they weren't concerned with at all.

Everyone interested in adding to his knowledge of the watercolor medium should study Turner.

## Girtin (1775–1802)

Thomas Girtin has somewhat less to offer today's student than Turner, his friend and sketching companion. It's on record that Turner said, "If Tom Girtin had lived, I should have starved." A great tribute to a friend who died at the early age of twenty-seven, but an exaggeration.

Girtin was one of the first to work in big, simple washes without outlines.

He often worked on toned paper. He slipped now and then, falling into the error of adding too much calligraphy with a small pointed brush. However, he was a superb draughtsman.

His few great masterpieces—*Kirkstall Abbey* is one—are well worth a look. There's a color reproduction of it in *A History of British Watercolor Painting* by H. M. Cundall, published by Scribner's in 1929. Study this magnificent watercolor for its beautifully balanced composition. Note that although it shows us miles of English countryside, the complex landscape has been handled with great simplicity and restraint. Not a tonal value jumps out of place. The design of the picture space leads the eye to the ruined tower, which becomes the single dominant point of interest. A quiet mood but a powerful watercolor.

## Cotman (1782–1842)

John Sell Cotman, another friend of Turner, kept his individuality. He was ahead of his time and not truly appreciated while alive. He was more interested in design than in atmospheric effects. Because of this, he's been rediscovered. His rich, flat surfaces, with their abstract qualities of design, appeal to painters today. His watercolors are realistic, but not naturalistic: he used natural forms to create a beautiful rhythmic pattern, set down in the simplest terms. Toward the end of Cotman's life, Turner got him a job as an art teacher. He died unappreciated, except by his fellow artists. Study his watercolors for the excellent design of the picture space. Note the unity and oneness of his composition. His *Greta Bridge* has been called the perfect watercolor. The original is in the British Museum, London.

## Bonington (1802–1828)

One of my favorites is Richard Parkes Bonington. He was the greatest of street scene painters. The sheer brilliance of his execution has charmed generations of serious students of the watercolor medium. Without a doubt, his early death robbed the world of many great paintings. He was a friend of Delacroix, who turned Bonington's attention to figure painting; this phase of his work is not as interesting to us today as his landscapes. There's a story of a Paris errand boy who stopped to see some Bonington watercolors displayed in a shop window; he was so impressed that he decided to become a painter himself. The boy's name was Corot.

Study Bonington for his amazing dexterity and wonderful draughtsmanship. Unlike Cotman's, his pictures are filled with light and atmosphere. He was among the first to make use of drybrush to add textural interest. However, he never overdid its use. He's a great master who shouldn't be missed.

**New England Harbor,** watercolor on paper, 20" x 28".

I've seen Rockport harbor at all seasons of the year and under all weather conditions. I've even experienced two hurricanes there. I've been a member of the Rockport Art Association for many years and number among my friends many of the year-round artist residents of the town: Jerri and Arnold Knauth, Tom Nicholas, and Don Stone, to name just a few. The harbor is the place where the famous Motif Number One is to be found, perhaps the most painted building in the world. Someone once reported seeing a painting of that old landmark in an exhibtion in Venice, Italy. The building in my picture is not Motif Number One, but it's sometimes called Number Two. This is one of my early morning paintings. I remember the air was so damp with clearing sea fog that the color washes just wouldn't dry. Rather than give up, I got out my tube of opaque white and ended up with what's almost a gouache treatment. I'm glad I did because there's a misty quality in the original that's not quite captured in the black and white reproduction.

**One of the Rocks,** watercolor on paper, 21″ x 27″. Albert Dorne Collection, Adelphi College, New York.

*Another Cape Ann subject, this was painted in the studio from a quarter sheet study made at Bass Rocks, Gloucester. There's just enough of the ocean showing at the right to make it coastal. The color of the rocks in this area is best described as tawny. Yellow ochre, burnt sienna, dirty yellow-gray, and dull browns predominate. Those below the high water mark are covered with rockweed—dark green, almost black, when wet. There's none showing in this picture. The smaller*

*sktech done on the spot was painted looking into the light—a habit with me. I like a bold silhouette and strong top lights. Except for the gulls and a bright light around the peak of the pointed rock in the center, the entire picture was built up with superimposed transparent washes and some drybrush for textures. For the gulls and the light spot I mentioned, I used opaque white. The figure against the sky was indicated smaller than he'd actually be, in order to give the rocks bigness.*

## de Wint (1784–1849)

Like Constable, Peter de Wint was a natural painter who loved to paint the English countryside in all its lush summer beauty: the heat of midday in the harvest field, trees in full foliage over a shady stream, and farmyards were his favorite subjects. He painted rapidly from nature with a large, fully loaded brush—a practice I commend most sincerely to all landscape painters in the watercolor medium. Study his simplicity and direct approach. He has had a great influence on my own work.

So much for the great ones of the early English school. If you're interested and want to do some research, here are some other names to look for: David Cox (1783–1859); William Callow (1812–1908); Thomas Collier (1840–1891); Samuel Palmer (1805–1881).

## Homer (1836–1910)

How about American masters? Well, we had some good men also. In watercolor, we started later than the English, although a good case could be made for John James Audubon (1785–1851) and George Catlin (1796–1872), painter of the plains Indians. These two artists were specialists, great painters, but separate and apart from the mainstream.

I think today's student should start with Winslow Homer. His late works, painted after he'd given up commercial illustration, are the best. In them he cast aside the opaque treatment of his early watercolors and painted in bold, simple, transparent color washes over a sketchy pencil drawing. These are his masterpieces. Painted during vacation trips to the Bahamas, Florida, and the north woods, they should be studied for their understatement. He appreciated the strength and beauty of simplicity. Study how he could reduce a complex subject to a few clear, bold washes, with detail merely suggested—a great lesson in the art of watercolor painting.

Writers are fond of quoting the old Yankee master. He's supposed to have said, "If I am to be remembered, it will be for my watercolors." Interesting if true. Any student with a tendency to overwork in watercolor will benefit by a study of Winslow Homer.

## Sargent (1856–1925)

The only other American of that period to equal Homer in importance, in my opinion, was John Singer Sargent. His watercolors were also vacation pictures, painted to relax from his busy life as one of the world's most successful portrait painters. When studying Sargent watercolors, note how swiftly his brush must have moved over the paper, but also notice the expert drawing beneath the brushwork. He was a dead shot draughtsman—a fact that no amount of facile technique can hide.

**The Beachcomber,** watercolor on paper, 20″ x 28″.

*I'm glad I don't have to pay my wife for modeling the small figures she's posed for in more of my pictures than I can remember. You just have to cover the figure in this one to see how much her presence contributes to the success of the composition. Good subjects sometimes happen as if by magic. This one did. We were on our way back from Brace's Cove, near Gloucester, where I'd been sketching. It was a long walk to the highway over the rough, rocky beach. I was walking ahead with my gear. Elsie, as usual, trailed behind, picking grasses and weeds for a dry bouquet. I turned to see where she* *was, and there before me was this beautiful, ready-made composition. The warm, gray sky, the lightstruck ocean, the rocky beach with its clutter of wreckage and sea weed—they were enough to send a painter out of his mind. The rocks are silver grays and tawny yellows. The mass of dried seaweed in the foreground is burnt umber and raw sienna. The grass area near the figure is yellow ochre, orange, and burnt sienna. The figure is wearing a white shirt, red sweater, and dark blue slacks. If you were to ask me to name my favorite pictures, this sure would be among them.*

## Contemporary Americans

Who else among the Americans? Well, there were hundreds of minor artists painting in watercolor. I must, however, come down to more recent times to find any of real significance.

John Marin (1870–1953) is held in great esteem by many. He's even been called our greatest watercolor painter. Sorry, but I don't go along with that. I think he was possessed of astonishing talents. I also think he lacked self-discipline. He created some beautiful color notes, tastefully arranged. If that satisfies you, then you may find his work extremely interesting. I admit to having a blind spot when it comes to Marin.

The mainstream of American art has always been realism and this is especially true of our watercolors. Abstractions and experimental works are shown in the big annual exhibitions, but most of the wall space is taken up by realistic paintings. This is particularly true in the East. On the West Coast, there's a strong school that favors a semi-abstract, more decorative approach. I've no intention of discussing the merits or demerits of my contemporaries. However, I do want to mention two masters of the medium . . .

The first is Edward Hopper (1882–1968). His watercolors of Maine lighthouses and the Cape Cod scene are worth a good, long look. Note again the understatement and the beautifully balanced composition—very realistic, but by no means photographic.

It surely isn't necessary for me to end this brief history by advising students to study the watercolors of Andrew Wyeth. So much has been published and so many exhibitions held that I would think every student in the country has seen the work, at least in reproduction, of this great contemporary. His pictures should be an example to the student who complains about having nothing to paint—the one who thinks he'd be able to make better pictures if he could only go to Spain, Mexico, or Timbuctoo. Wyeth stays home and paints fine pictures of everyday things and places. His works are realistic, but based on a good abstract pattern. It's this that lifts his work out of the ordinary.

These, then, are the men, past and present, who've interested and influenced me. I think their work should be of interest to all students of the watercolor medium. At the end of the text, there's a checklist of the books I've read and recommend on the subject.

## How to Study

How does the beginner start to study watercolor? First, read as much as you can about it. While doing this, join a class, if possible. Don't underestimate the value of contact with other students. You'll learn a lot about watercolor by watching others do it. Try to work with a good instructor. Do as he suggests, at least for the first year. Originality, if you have any, will come into your work in time. You won't be able to stop it. Keep in mind

that you learn to paint by painting—so paint, paint, paint!

Go to exhibitions where watercolors are shown. If you have an art museum in your city, go there and ask to see a list of the watercolors in the museum's collection. Check the ones you want to study. If they aren't on view—they seldom are these days—ask that they be brought out of hiding. Make an appointment to go and view them; if you show a genuine interest, you'll receive courteous attention.

That's the right way to study.

What's the wrong way? First of all, don't try to outsmart your teacher. If he's a professional, get the idea out of your head that you can fool him. You can't. Don't try to alibi your way out of a sorry mess with fast talk about trying for "something different." Frankly admit that you made a boo-boo. Ask his advice and start over. This sort of thing does happen, believe me.

If you have a choice, select your instructor with care. An artist who has a good exhibition record, and whose work you admire, would be a good bet. If he can paint a decent demonstration picture in class, you probably have a good instructor. On the other hand, if your man is all big, wordy talk and no action, look around for a new teacher.

How about influences? If you're a beginner, you'll no doubt be influenced by your instructor; most beginners are. As you acquire skill, you'll probably find your watercolors resembling your teacher's work. Don't worry about it. It happened to all of us at the start. It's when the more advanced student *deliberately* imitates the instructor's work that the situation becomes dangerous. Some people deceive themselves into thinking they've accomplished something by producing a picture that could be mistaken for one by their teacher. Actually, all they've done is to prove that they're skillful copyists.

Even good painters sometimes get trapped by their admiration for an artist who may be having tremendous success at the moment. Look at the hordes of Wyeth imitators, for instance. By all means, study the work of your contemporaries; but then go to nature and slowly develop your own personal style. You'll get more satisfaction in the end.

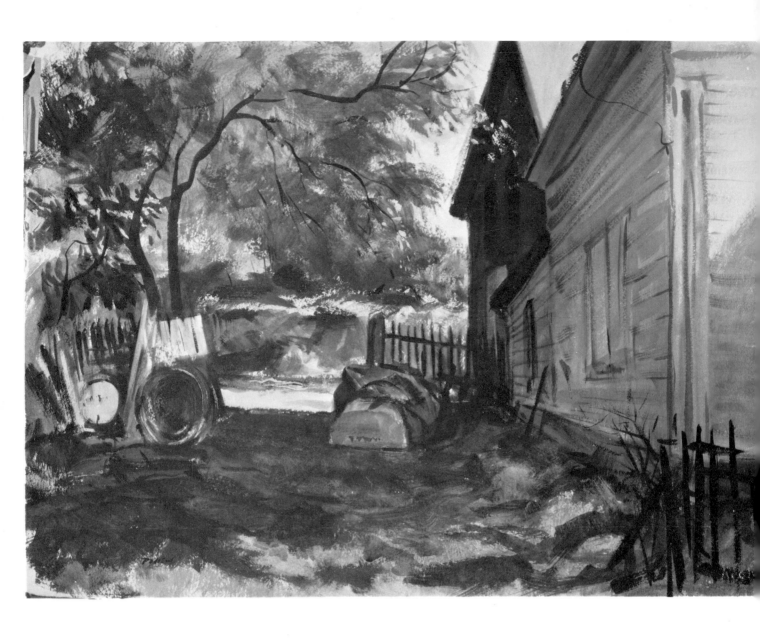

**Fisherman's Yard,** watercolor on paper, 15″ x 20″.

*Back yards are interesting places. They tell you much about the people who live in the house that the yard belongs to. There are neat yards, untidy yards, and just plain sloppy yards. There was nothing to complain of in this New England yard. The light and shadow pattern was what attracted me. Except for a triangle of light in the upper right corner, and a few spots of sunlit grass along the picture's bottom edge, the side of the house and the entire foreground are in shadow. There's a very bright splash of sunlight in the lane beyond the fence. The wide yard gate was open and a grand contrast was created between the cast shadows of the house and the brilliant sunlit area. The composition was ready made: an upturned boat in the right place to break the line of the gate post, this balanced by a coil of wire and an oil drum on the left, with the tree branches designed by nature to carry the eye back to the house. Nothing to do but paint it.*

# Tools and Materials

Can you tell a good workman by his tools? By the kind of tools he uses? By the *quality* of his tools? The answer is no, you can't. One of the country's most skillful watercolor painters has never owned a sable brush. Another makes beautiful drawings with a twig, picked up on location, and dipped into a bottle of ink.

Stick and ink drawings. *The pot of brushes and the Colorado ghost town street were drawn with a piece of wood sharpened to a rather blunt point. If you have a tendency to get tight in your drawing, try it. It will shake you out of your rut.*

## Keep Your Equipment Simple

I don't suppose there's ever been a time in the history of art when such a variety of equipment and supplies has been available to the artist and student. Manufacturers' catalogs are packed with more goodies than the gardener's annual seed catalog. New gadgets to tempt the amateur appear yearly. Some are interesting; many of them are unnecessary.

Actually, very few tools are needed to paint a watercolor. This is especially true of painting outdoors, where you must consider the weight to be carried. Especially when I'm painting from nature, I believe in traveling light. Here's what I consider essential . . .

## Brushes

First the brushes. I can get along quite well with four: a 1″ flat; a number nine round; a number seven, also round; and a small, pointed, round brush for fine lines.

If you like the feel of sables and can afford them, buy them. But you can use oxhair brushes, which are much cheaper. I use them often and like them. I also use a large oil painting brush (bristle) which I find just great for large washes. So much for brushes.

However, the 1″ flat is the most useful brush for painting a half sheet watercolor (15″ x 22″). I have both sable and oxhair in this size and I paint most of my picture with one or the other. The 1″ brush will hold enough paint and water for a good sized wash. It can also be held in an almost vertical position to take advantage of its 1″ long, sharp edge to draw thin lines. Loaded with paint and little water, it can be patted flat on the paper to create an interesting kind of drybrush texture. You may also spread its hairs by pressing it down on the palette and then, with a rapid upward stroke, create another drybrush effect that suggests grass or weeds.

Sable brushes, both flat and round, may have a little more spring or life in them than oxhair. That seems to be the only difference. I've painted some of my best things with oxhair brushes and some of my *worst* with sables. Blindfold me and I don't believe I could tell the difference.

If you use an oil painter's bristle brush for large washes, be sure you clean it well after using. Paint seems to settle around the bristles in the heel and becomes more difficult to remove than in the soft hair brushes. Wash the bristles well with warm water and soap.

Some instructors can write many words of wisdom on what different brushes can be made to do, how to make them behave, etc. This is school teacher talk. I remember my kindergarten teacher teaching me how to press a round watercolor brush on paper to make a flower petal. After considerable practice, I could place these marks in the form of a circle, put a stem on them, and make a whole flower! I've never found a use for this great accomplishment—and hope I never shall.

Beginners attach too much importance to the size and shape of brushes. They think that if an admired artist creates some tricky brushwork, it's because of the size or the kind of brush he used. Nonsense. It's not the brush. It's the brain and experience behind the brush. To use a brush only to obtain some special effect is a sure way of becoming a mannerist.

## Paper

Now what about the paper we paint on? My advice here is to buy the best and the heaviest. It's difficult enough to paint any kind of a watercolor without having to struggle with the thin, cheaper kinds of paper. The two weights most often used today are 140 lb. and 300 lb. Unless it's used for

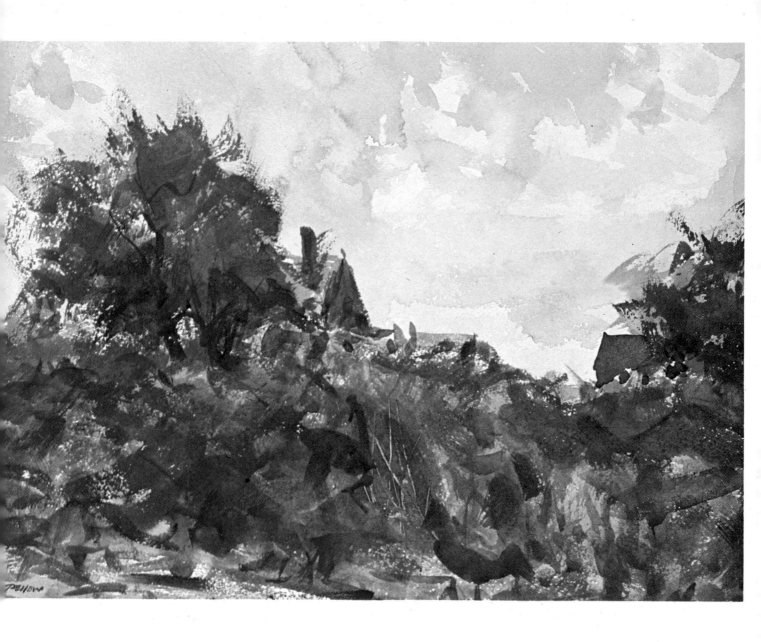

**A Cape Ann Farm,** watercolor on paper, 9″ x 12″.

*I suppose this could be called a quickie. I prefer to call it a small watercolor. The term "quickie" is often used in a derogatory sense, meaning something dashed off without much thought. I think all good watercolors are painted rapidly. Spontaneity is part of their charm. So, the fact that a picture is small needn't lessen its importance as a work of art. What has the time taken to paint it got to do with its quality? If this one was painted on a 22″ x 30″ full sheet, I don't think it would be any better. As a matter of fact, it might not be as good.*

   *It was painted one breezy September day, near Lanesville. I tried to get a feeling of wind into it without being too obvious about it. When I'd finished, I found I'd broken one of the old standard compositional rules. I'd divided my space through the center by making the sky and land areas equal—but it doesn't bother me a bit. Notice how the detail of the foreground bank has been merely suggested: just bold brushwork to establish its character. Also note the drybrush edges in the foliage of the trees.*

very small pictures, the 140 lb. will buckle and should be stretched. I use 300 lb., which is a stiff, board-like sheet that can be used on both sides and doesn't need stretching.

The correct side of any watercolor paper is the side from which you can read the trademark when the paper is held up to the light. That's the side I always start on, but I get some of my best pictures on the wrong side after a too timid start on the good side. I guess the reason for this is that once I've worked off my fear of spoiling that beautiful white surface, I figure, "what the hell, now let's have some fun." I often wonder why I don't *start* on the wrong side, but I never do. It might have something to do with the time when I was young and poor and good watercolor paper cost what was a lot of money to me then.

Watercolor paper comes in three surfaces: hot pressed, which is smooth; cold pressed, which is medium rough; and rough. I prefer the cold pressed. It has a nice, medium grain—not too smooth, not too rough—suitable for small or large pictures. Many like the rough, but I find the prominent texture troublesome in pictures smaller than a full sheet, which measures 22″ x 30″.

The beginner should experiment with papers of different makes and surfaces. When one brand of paper is found that seems better than the others for your purposes, stick to it. Get used to a paper. Know what to expect from it. And don't be afraid of spoiling a sheet. Remember, there's always the other side.

How do you find the perfect paper? Even professionals don't agree on paper. The one thing they *will* agree on is that the best watercolor paper all comes from abroad. The English, French, and Italians all manufacture good artist papers. However, even they aren't always perfect.

Some will repel water as the brush is passed over them. This is due to the water-resistant size on the surface; you'll see the size float off. The paper can be brushed down with water to reduce the effect of the size, then put aside to dry—unless you want to work on wet paper.

When I say you should experiment with different papers, I mean that you should actually paint on them. Set up a still life and paint it on one paper. Then paint it again on a different type or brand of paper. Make notes on how the sheet reacts. Don't trust your memory. If one paper is more absorbent than the other, you may like that quality. On the other hand, you may not. Test several kinds. You'll find that drybrush is easily done on a paper with a rough surface, but difficult on a smooth one. You may find that you like paper of the 140 lb. weight, or you may discover that only the more expensive 300 lb. paper suits you. You can only know for sure by running a few tests.

When you've run your tests, made your decision, and found a paper that you like, just hope that the manufacturer will hold the quality line. I know one very popular paper, for example, that has changed a great deal in the past five years!

## Watercolor Boxes, Palettes, Brush Holders

There are many types of watercolor boxes on the market, some good, some not. Don't buy a box fitted with pans of color. They're only fit for children to play with. If you must have a box, get one that will hold tube colors.

The advantage of tubes over pans is that fresh, moist paint is always available in the tubes, while the paint in boxes fitted with those little pans gets so hard it takes forever to work up a good wash. Winsor & Newton have a color box that contains pans of their "moist watercolors," which are quite good for small sketches; but I still prefer the tubes. Of course, you can get empty partitioned boxes and squeeze your tube colors into the partitions. This works well for outdoor work. I used such a box for years. It was made by Robersons, an English firm. I used it so much I actually wore it out and haven't been able to find another.

Let me confess right now that I never carry a watercolor box. A folding palette, yes. My tubes of paint go into a nice, flat, round tobacco tin. I carry the brushes in what was once an umbrella sheath. I picked it up on Fifth Avenue one rainy day. After cutting the bottom off and sewing it up, I found that it made a perfect brush holder. It's tough and waterproof and has been part of my kit for many years.

For those who feel that they must have paints, brushes, and palette all in one box, here's a sketch of one that should be satisfactory. The folding palette acts as a lid. I bought one because I wanted the palette. I leave the box part at home.

There are separate watercolor palettes on the market—ones that you don't have to buy with a box. Unfortunately, most of them seem to be made of plastic. I've never found them to be as good as the enameled metal kind; the plastic ones are too light in weight and the color doesn't seem to mix as well on them. In the studio, there's no better palette than a butcher's enameled tray or a sheet of white glass.

Paintbox and palette. *I've found this type of box serviceable. The palette slides into a groove, forming a lid. Actually, I carry the palette and leave the box at home. My tubes go into a smaller round tobacco tin.*

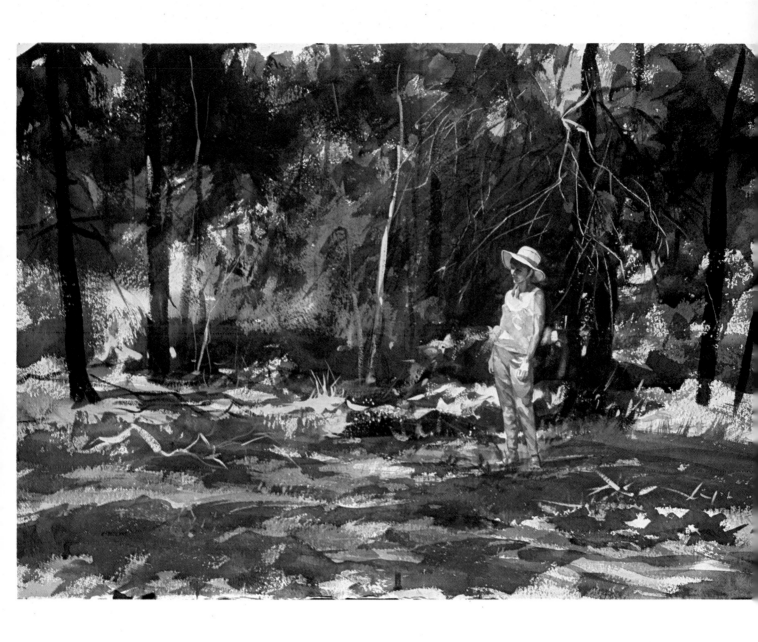

**Marianne,** watercolor on paper, 22″ x 30″  Collection, Marianne Moscal.

*The French Impressionists were fond of posing graceful young women out-of-doors, surrounded by flickering sunlight and summer greenery. Renoir and the others did some lovely things with this kind of subject matter. I too have enjoyed it. I certainly found painting this one a pleasurable experience. I was once asked why I put more women in my pictures than I do men. I don't know—haven't artists always? Let me tell you how this picture came into being. I was in Colorado with a workshop group. One morning, we arrived at a spot that had been recommended as a good place to paint. It wasn't. Most of the group were so disappointed that they returned to Durango. Not me. The sun was shining through the trees, creating a marvelous pattern of lights and shadows. With a young woman present in a charming costume, I certainly wasn't going back to Durango to paint the railroad station!*

*You must learn to see picture material. Don't wander around looking for something better. The best might be right where you are.*

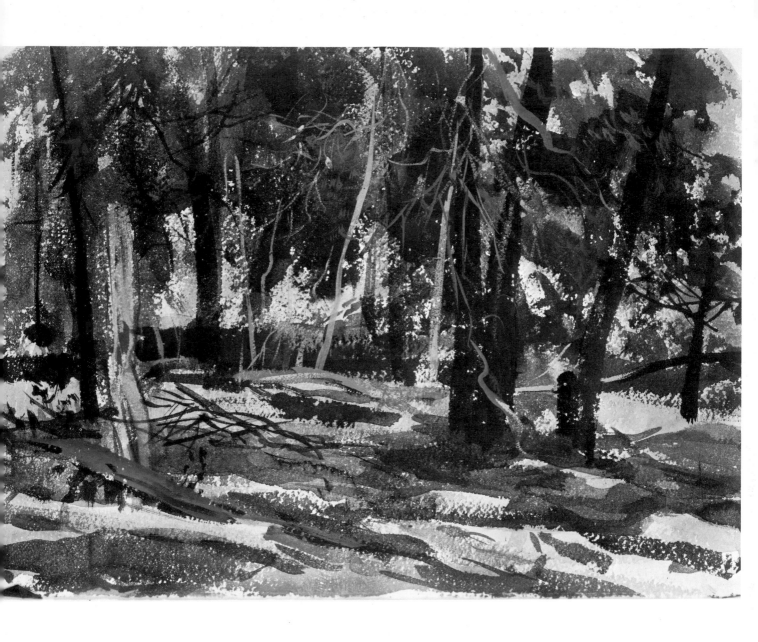

**Background sketch for Marianne** (see color plate).

*This quarter sheet watercolor was painted near Durango, Colorado, though it could be woodland almost anywhere. It served as a warmup for the forest background of the picture titled Marianne and reproduced in color. I've always liked the flickering sunlight and shadow of* *wood interiors. I feel that this sketch is quite successful in capturing the illusion. My usual procedure is to establish the pattern of light and dark made by the foliage and seen on the ground area first. After doing this, I put in the treetrunks.*

## Paints: List of Colors

Now we come to the paints themselves. Just for fun, the beginner should look at the color manufacturer's catalog—just for fun, that is. You can buy rose carthamé, periwinkle blue, brown pink, and others with even more fanciful names. But don't. Most amateurs carry a much greater variety of colors than the average professional. Five or six colors are all that are necessary. I actually have ten tubes in my little tobacco box, but I seldom use more than four or five on a picture. Here's my list of colors for both outdoor and studio work.

*Cadmium yellow light:* A heavy, relatively opaque pigment. I seldom use it in a wash, but I find it useful when mixed with opaque white for small, bright lights, such as the sparkle of sunlight among dark foliage in a woodland scene. I find it too opaque for most transparent watercolor work.

*Gamboge yellow:* A beautiful brilliant yellow with which good transparent washes can be obtained. It has none of the opaque qualities of cadmium yellow. I use it with a touch of phthalocyanine (thalo) blue for mixing greens.

*Yellow ochre:* A natural earth color, dull yellow or tan, useful in all landscape work. I often give my paper a pale wash of ochre prior to painting with the other colors. Mixed with blue, it produces semi-opaque greens.

*Raw sienna:* Another earth color, darker than yellow ochre, and a favorite color of mine. It's great for mixing with thalo blue to obtain rich greens. It's also good mixed with reds and browns for autumn landscapes.

*Cadmium scarlet* (Winsor & Newton): The only real bright red in the box. When you need a "spot of red," this is it! Cadmium scarlet works well in transparent washes. Mixed with burnt sienna, it takes the place of Venetian and English red.

*Burnt sienna:* In transparent washes, it's a fiery, almost red orange, a good color in autumn landscapes, but also useful for mixing with blue to obtain deep greens.

*Burnt umber:* The only dark brown on my palette. I use it mixed with blue to create grays. A touch of it will take the rawness out of a too bright blue.

*Phthalocyanine (thalo) blue:* A fine blue, but one that needs careful handling. It's a strong staining color that can take over the whole picture if you use it indiscriminately. It's excellent for light, transparent washes in skies —but use plenty of water with it. It's also good in green mixtures—with gamboge, raw sienna, burnt sienna, etc.—as noted above.

*Cerulean blue:* A heavy, dense pigment that will settle into the grain of watercolor paper, creating textural effects that are sometimes useful. I use it now and then for cool tones in the distance. It's a rather "pretty" color that should be used with discretion.

*Opaque white:* If you feel as I do that a tube of opaque white is a handy thing to have along, then Winsor & Newton Designers Gouache White is a good one. It has other uses than for solid, opaque touches. For instance, a little added to color washes will produce pearly tones obtainable in no other way.

That adds up to ten colors, including the white. I use only four or five for any one picture, but I don't use the same set for all subjects. Notice that I have no prepared greens on my list. Greens are mixed with combinations of yellows and blues as I work. I dislike most tube greens; the popular Hookers green I *detest.*

Color is a very personal thing. The ones that suit me might not suit another. I think the beginner should experiment to find the right colors for *him.* However, keep the list simple. Have too few rather than too many.

Here are some other colors that are used by watercolor painters. Some of them can be quite useful. Try them all. In a year or two, you'll find that you've settled on a workable dozen.

*Payne's gray:* A mixture of ultramarine blue, black, and yellow ochre. I use it, but I can get along without it by using a mix of thalo blue and burnt umber. Beware: Payne's gray dries *much* lighter than it appears when wet.

*Alizarin crimson:* A deep, rosy red, clear and transparent. Rich darks— more luminous than those obtained with black—can be made with mixtures of alizarin and thalo blue. Alizarin is very useful in flower painting.

*Cadmium orange:* A good bright orange for those who are too lazy to mix yellow and red to make orange.

*Cobalt blue:* Bright and clear, almost transparent, cobalt blue has a rather greenish undertone. It's useful in distant parts of a landscape to obtain recession, or mixed with yellow ochre for greens.

*Hooker's green:* A mixture of Prussian blue and gamboge—somewhat olive in tone—Hooker's green can be purchased in two shades: one bluish, the other more yellow. It's not permanent.

*Viridian:* A beautiful green, cool, clear, transparent, and absolutely permanent. If you must have a tube of green, this is it.

*Ivory black:* Really high grade bone black, not necessarily made from ivory. I think this the best black for watercolor work, although some prefer lamp black, which is carbon. Ivory black can be mixed with yellows to obtain greens; or a touch of it can be used to tone down a too brilliant blue.

*Raw umber:* A dark brown with a green-gray tone, not as warm in color as burnt umber. I discarded it years ago for watercolor work.

*Ultramarine blue and Prussian blue:* Although these blues are widely sold, I feel that thalo (phthalocyanine) blue has taken their place in the color box. I no longer use either of them.

## Easels for Outdoor Painting

What about easels? There seem to be two schools of thought on whether or not an easel should be carried on an outdoor sketching trip. Norman Wilkinson, the veteran British watercolor painter, calls a sketching easel an infuriating piece of gear. A cheap one certainly can be. Nevertheless, here's a sketch of the type of easel used by most professionals who paint watercolors outdoors. It will tilt to any desired angle. It's sturdy and strong —also heavy and quite stable.

I must admit that I've never used this one. On the contrary, I use the same easel for all mediums: oil, acrylic, and watercolor. It's called the Anderson or Gloucester easel—actually designed for oil painters. This easel has no bolts, nuts, or screws to get lost. And because I work with my paper in an almost upright position, an oil painter's easel suits me very well.

Painting a watercolor upright must sound like a trick stunt by some kind of a nut. I assure you it isn't and I'm not. Let me explain. Some old timer once said that when you go outdoors to sketch, you should first find a shady spot to sit in, then look around for something to paint. Fair enough. Like most people, I can't paint with the sun shining on the white paper either.

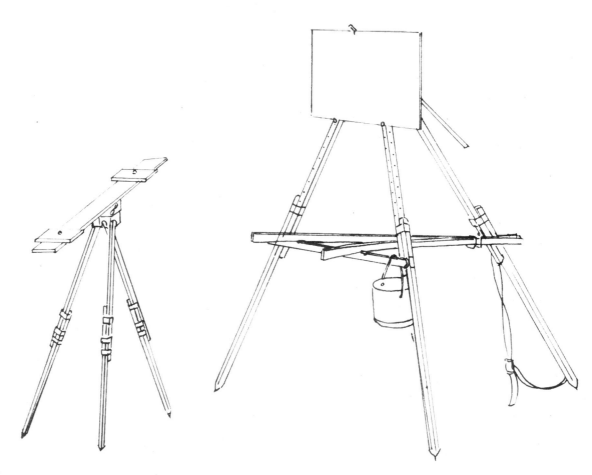

Easels. *The easel on the left is the one most popular with watercolor painters. For working upright, I use the Anderson easel shown at the right.*

But I don't sit down to paint and often the only available shade is *not* where my subject is. So I place my sheet—backed up by a board—upright on the easel with its back to the sun, putting my paper in the shade. I may get sunburned, but I don't get half blinded by the glaring white paper.

Is it difficult to paint a good watercolor with the paper upright? It's difficult to paint a good watercolor—period. However, the many students and amateurs who've watched my demonstrations know it can be done. This method is not for the painter who paints only on wet paper; I keep the wet in wet technique for studio work. On location, I haven't time to fool around. I want to get it down as fast as possible. Painting directly on the dry paper seems to be the quickest way.

Painting a watercolor upright isn't as difficult as you may think. I know several painters who do it. A wash that contains a lot of water will run downward, of course. Keeping an eye on the runs—and mopping them up with the brush before they can do any damage—is a matter of practice. There's no other trick to it. You just go ahead as you would if you were painting on a horizontal sheet. Of course, the picture must be painted directly on dry paper and not on paper that has been soaked prior to painting. The upright method is great for demonstrations because it's so easy for the audience to see what the demonstrator is doing. That's it—go ahead and try it. You may like it or you may decide that those of us who paint watercolors upright are nuts after all!

The Anderson or Gloucester easel, set up and folded, is shown in the sketch of my complete outdoor equipment.

## Accessories

What else is needed? A board is necessary to hold the paper. I use a piece of plywood, cut a little larger than the 15" x 22" half sheet papers I work on. It's a good idea to give the board a couple of coats of house paint on both sides to waterproof it. A pair of clips can be used to hold the paper on the board, or the sheet can be fastened by its four corners with small pieces of masking tape. This is my method; masking tape never gets in the way, while clips sometimes do.

A water container is a must and I have yet to find anything better than an army canteen. There must also be something to pour the water into. Here I make use of the bottom half of a plastic bleach bottle; cut off the lower part with a razor blade, poke a couple of holes in it for a string handle, and the result is a lightweight, unbreakable water jar that can hang on the easel. The canteen fits into it when packed for travel.

Paper towels—the folded kind that fit into washroom dispensers—are useful and have taken the place of paint rags in my kit. A plastic sponge is handy too.

What's the best way to carry this equipment? I use a small knapsack, purchased long ago in an army-navy store. An airplane bag is also very

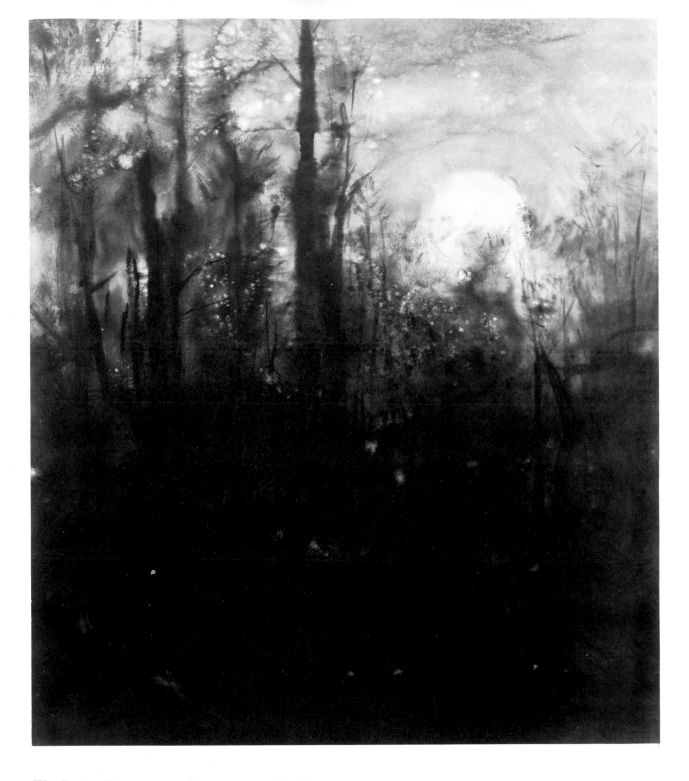

**The Rising Moon,** watercolor on paper, 25″ x 30″.

*I'd consider this a good example of memory painting. I used the system that Whistler is said to have used in painting his famous nocturnes of the Thames from the Chelsea Embankment. He'd view the scene with a friend; after taking it in for several minutes, he'd turn his back to the view and tell his companion what he'd seen. I've watched the moon come up from behind the trees at the back of my studio many times—always a thrilling sight. One crisp winter night, I stood on the lawn with a friend and watched the full moon rise.*

*Talking to him about it seemed to fix the scene in my mind much better than I could have done alone—the Whistler system. The next morning, I painted the picture in the studio from memory. This is a very wet watercolor, done on paper soaked for so long it was dangerous to lift it from the tub. To obtain the darks in this painting, I had to pick up brushfuls of almost pure pigment. To obtain the light spots, I spattered on clean water by tapping the brush on the edge of a ruler.*

good because it has a flat bottom on which to place the paintbox or palette. I've seen painters use a fisherman's tackle box; others have used a similar box made for sign painters. The last two boxes are too big and bulky for me; the small amount of stuff I carry would just rattle around inside them. I've seen sketchers with so much gear packed into boxes of that kind that it was a major operation to locate anything that wasn't right on top.

My board and paper go into a flat canvas envelope that any wife or girl friend can sew together.

Here's a drawing of my complete equipment for outdoor painting.

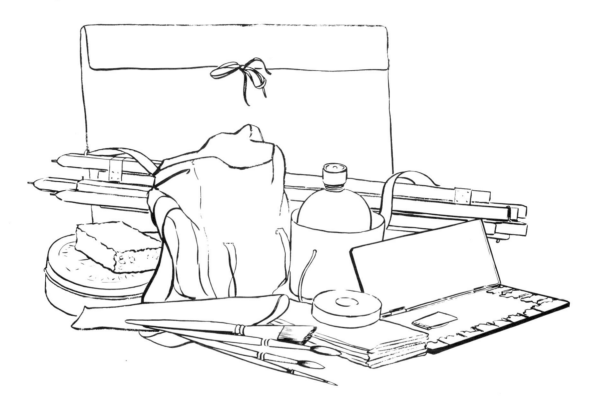

Equipment for outdoor painting. *The canvas carrying case contains a plywood board and watercolor paper (300 lb.). The Anderson easel is shown folded. Into the bag (with shoulder strap) go all but the easel and the carrying case. On the left, note the sponge and round tobacco tin that holds tubes of color and razor blade. Four brushes are usually carried: 1" flat, and numbers 10, 8, and 2 round. The rounds, as a rule, are sable; the flat is sometimes oxhair. Just above them is the old umbrella sheath in which I carry the brushes. Note also: paper towels, roll of 1" masking tape, water pot and army canteen, flat folding watercolor palette.*

**Cape Ann Country,** watercolor on paper, 15″ x 20″.

*This painting should convey a feeling of early morning. It was painted from atop a sand dune, looking toward the city of Gloucester, which lies beyond that distant strip of land. I think the time was about 8 A.M. Those deep, long, cast shadows from the trees will bear me out, I hope. Jerri Ricci still kids me about my enthusiasm for the beauty of early morning painting, with its deep, rich color, and those long cast shadows. We spent many a morning, half asleep, trying to put it down on paper. This stretch of dunes was one of our favorite hunting grounds. This is truly a transparent watercolor. The white paper gleams even through its darkest darks. The light stretch of water in the upper center is untouched paper. There's thalo blue and Payne's gray in the large shadow area below the trees. In the distance, there's some cerulean blue, a color I seldom use. It seemed just the right blue that morning. Notice how the drybrush texture used in the tree foliage adds variety, contrasting, as it does, with the simple, flat washes.*

# Exercises for Beginners

Chapter 3 of my book on *Acrylic Landscape Painting* was also concerned with brush exercises. In it I admitted that exercises bored me. I stand by that statement—they really bore me. Let me put it this way: you don't learn to drive by sitting in a stationary car, practicing shifting gears and wiggling the controls; you learn by experience on the road under all sorts of conditions. You learn to paint watercolors the same way—by experience. After you've painted 500 watercolors, you may, if you're fairly bright, know something about the medium.

On the other hand, the real beginner who's never held a watercolor brush in his hand until now may find doing the following exercises beneficial. On the other hand, if you're as bored by them as I am, skip this part.

## Drybrush

The three technical procedures that make up 90% of all watercolors are drybrush, graded wash, and wet-in-wet.

Drybrush can be used to suggest detail and to add textural interest, but it should *never* be overdone. Color is laid on with the brush rapidly skimming the surface of the paper, depositing color only on the ridges of the paper's irregular surface. Owing to the texture of the paper, or to an exact estimate of the amount of pigment and water in the brush (which is kept fairly dry, not loaded) the color appears with innumerable gaps which allow the undertone to break through.

You can control the dryness of the brush by keeping a paper towel handy and sweeping the wet brush over the towel before you attack the painting. You may also want to try holding the brush almost parallel to the paper—rather than at a right angle to the surface—so the tips or *sides* of the bristles barely graze the surface.

Drybrush has many uses. It can imitate the rough bark of a tree or the grain of a plank; the weathered surface of a plaster wall; pebbles on a sandy shore; or the sparkle of sunlight on distant water. But this sort of effect should be used with discretion. Remember my warning: never overdo it.

*Experiment to discover the many textures that can be obtained with drybrush. Push, drag, or pat the brush onto the paper.*

## Graded Wash

The graded wash is most often used by watercolor painters to grade a sky from dark at the zenith to light at the horizon. To obtain a good graded wash, start with plenty of paint on the brush. Make a big stroke across the top of the sheet. Assuming you're painting on a board that slants toward you, some of the paint will pool at the lower edge of the stroke. Now load your brush with the same color, but a bit more water. Make another big stroke beneath the first, just slightly overlapping the dark pool of paint at the bottom of the first stroke. The two strokes will flow together and a new, slightly lighter pool will form at the bottom of the second stroke. Continue this process—adding a bit more water and a bit less color to the brush each time and overlapping the bottom edge of the preceding stroke—and you'll see the sky get progressively lighter as the wash progresses downward toward the horizon. Beginners find this difficult, but with practice and patience, like pingpong, it can be learned.

Some painters like to wet the sky area first with clean water. When you apply successively lighter strokes to the wet paper, they automatically flow together and blend. This is more like painting wet-in-wet.

A flat wash, by the way, is done in the same way as a graded wash— either on dry or wet paper—but each stroke is kept as dark as the one before.

*The graded wash is often used to paint a clear sky. Start at the top and gradually add water to the brush as you progress toward the bottom.*

## Wet-in-Wet

The wet-in-wet exercise is easy and fun to do. Perhaps that's why some students go on painting wet-in-wet pictures and never change. If you're the type that flips over cute, colorful blots run together, then it's for you. However, learning to control wet-in-wet passages so that they become part of a planned scheme is quite another matter. Used in this way, the wet-in-wet technique is capable of beautiful results. In pictures where I've used a great deal of wet-in-wet, I try to calculate the results ahead of time. If an accident occurs and looks good, I accept it with thanks. Why not? Maybe it's my subconscious working for me.

To practice the wet-in-wet method, merely paint a wash of fairly light color, then rapidly put a brushful of a darker color into it. The first wash must be still quite wet in order to have a successful blending of the two. You can exercise a certain amount of control by turning and tilting the paper in different directions. This technique is often useful in sky painting; you can wipe out clouds with a sponge while the sky is wet.

*All kinds of tricky accidents can happen when colors are put together wet. However, with practice, a certain degree of control is possible.*

## Superimposed Wash

The student *must* learn to handle a superimposed wash if he expects to do anything worthwhile in the medium. Simply stated, this means painting a wash of color over another wash that's been allowed to dry—and doing it without picking up any of the underwash.

The first try is often discouraging. The underwash smears, mixes with the overwash, and results in a streaky, muddy mess. When this happens, the luminosity of the white paper, gleaming through the transparent washes, is destroyed.

There's only one right way to do a superimposed wash. First be sure that the underwash is quite dry. Then paint over it rapidly with as large a brush as you can handle in comfort. Speed and a light touch are essential.

I suggest some practice on scraps of watercolor paper. Put down a wash of yellow—preferably gamboge, but cadmium yellow will do. (A superimposed wash will work best over gamboge as that color is thin and transparent; cadmium yellow is fairly heavy and opaque and the greater thickness of its paint layer will make it more susceptible to pickup.) Let the wash be about the size of a playing card. While the yellow is drying, mix a puddle of thalo blue. Now, using your large brush, paint a band of blue across the yellow. Working down from the first stroke, paint a second and a third band, joining each with the one above. If this has been done rapidly, the yellow underwash won't be disturbed.

When dry, the area where the blue crosses the yellow will be a luminous, transparent green, created by the yellow gleaming through the blue and the white paper gleaming through both. The same two colors mixed together on the palette *would* make green, but a green lacking the luminosity of the superimposed wash.

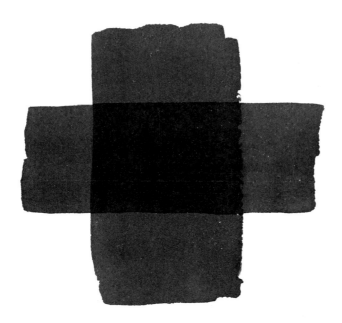

*A superimposed wash is a color wash painted over another that has been allowed to dry.*

## Spatter

Spatter, like drybrush, shouldn't be overdone. Because it's easy and fun, it can be a menace in the hands of students and amateurs who are easily led astray. It's a very easy technique.

One method is to tap a brush (loaded with paint and very little water) on the handle of another brush held in the left hand. A series of spots will fall onto the paper. With practice, the size of the spots can be regulated by varying the distance between brush and paper. Another way is to dip an old toothbrush into the paint and then draw a stick or the edge of a knife across its bristles, literally spraying the color onto the sheet.

Spatter. *Spatter effects aren't difficult to do. Just tap a brush, dipped in paint, on the handle of another brush that's held above and parallel to the paper's surface. With practice, you'll be able to control the size of the dots.*

## Lifting Out

Lifting out is a way of putting a light tone into an area that was previously painted dark. For instance, you may want to indicate lightstruck branches in a mass of dark foliage or a white seagull against a dark rock.

For branches, all that's needed is a small, stiff bristle brush (the kind used for oil painting) and some cleansing tissue. Wet the brush with clean water and scrub the place to be lightened; blot (don't rub) with the tissue, picking up the moistened color. On good paper, this can be repeated several times without damaging the surface.

The gull against the rock can be done in another way. Cut the bird's shape out of another piece of stiff paper with a razor blade, making a kind

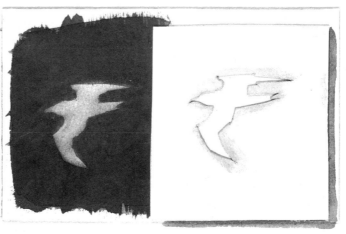

*To lift out branches (left), scrub the surface with a wet bristle brush and blot with cleansing tissue, which will pick up the moistened color. To lift out a more intricate, precise shape (right), make a kind of stencil by cutting the shape out of a piece of stiff paper. Hold the stencil in position on the painting and scrub through the hole with a bristle brush or a sponge, then lift the moist color with cleansing tissue.*

of stencil. Throw away the bird's shape that you've cut out and hold the paper in position on the painting. Brush, sponge, and tissue are used to lift the color *through* the gull-shaped hole. Why go to all this trouble when masking fluid could be used to retain the pure white paper within the dark areas? My thoughts on this will be included in the next chapter.

### Washing Out

Washing out differs from lifting out, which is used to deal only with small parts. In washing out, you deal with a large section, or even the entire surface of the picture.

Suppose the upper half of a painting turns out well, but its foreground is a dull, tired mess, due to overworking. What to do? Run some water in the bathtub. Hold the paper by its top corners and dip the bottom half of the sheet into the water. Hold it there for a minute or two, then place it against the side of the tub. With a soft sponge, wash the paint off the unwanted foreground. Lift the sheet and place it on the drawing table to dry. If a wet in wet treatment is desired, start painting on as soon as the excess water has been blotted up, but before the painting dries.

To wash the *whole* surface, simply place the sheet under water and lightly scrub with the sponge. In summer, I take the paper outdoors and use the garden hose. Some colors (like thalo blue) will leave a stain on the paper that no amount of washing can remove. However, I consider this an advantage. These stains often have a lot of charm. Turner's watercolors show evidence of washing out.

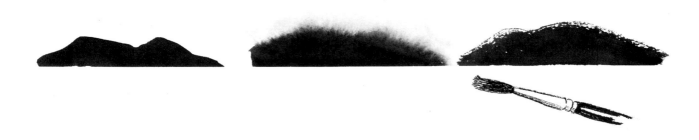

*The sharp edge at left needs no explanation. It is often difficult to avoid getting too many of them. The soft edge shown in the center can be obtained by painting up to a damp area and allowing the paint to blend softly; or a squeezed out, damp brush can be used along the still wet edge. Either way takes practice and experience. For the drybrush edge (right), flatten the brush as shown above and drag it along the edge in the direction of the stroke. Only experience can tell you how much paint and water the brush should contain.*

## Edges

There are three kinds of edges in watercolor: hard, soft, and drybrush. There's no need for me to tell anyone how to practice the first: you just paint a shape with a fully loaded brush on dry paper. How to *avoid* a hard edge is often the problem.

To practice the soft or blended edge, paint a band of color about 1½" wide and 4" long. Wash out the brush. Load it with a darker color and paint another band alongside the first—while the first is still wet—then bring them together. If the washes are too wet when joined, they'll run and the edge will disappear, resulting in a wet-in-wet passage rather than a subtly blended edge. Only practice and experience can tell you how much paint is needed on the brush, how wet or how dry the washes should be. The illustration shows how the blending should look when finished.

A hard edge can also be softened by running a damp, squeezed out brush over it—but this must be done while the edge is still wet.

The drybrush edge is simply drybrush applied to edges. When you get to the edge of a shape, drag your brush lightly over the "tooth" of the paper.

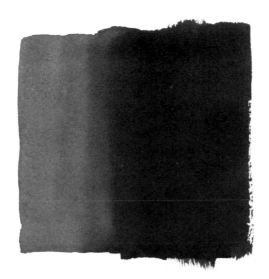

*A blended edge is created by two tones blended where they meet. If they are too wet when brought together, they'll run. If the first color is too dry, a hard edge will result.*

*To produce drybrush edge, paint the darker tone over the light one; then spread the brush and drag it along the edge where the tones meet.*

## Calligraphy

Calligraphy means using the brush to write linear symbols that give additional information about a part or parts of a picture. For instance, a series of short, curved strokes can be a symbol for waves. The French painter, Raoul Dufy, often covered a wash of green with loops and squiggles drawn with the point of the brush—his linear symbols for foliage. I give this as an example of calligraphy, not as praise of Dufy, whose painting I dislike intensely.

*Calligraphy is writing symbols with the brush. For instance, a bird in flight can be described with just two strokes.*

## Painting a Scene in Two Colors

Now let's get to the serious part of this chapter: a simple rendering of a scene in two colors. I feel that all the foregoing lessons are best learned by experience in actually painting pictures—doing certain things over and over with the brush until the action becomes automatic. Just like driving a car!

We'll use Payne's gray, a cool color, and raw sienna, a rich, warm color. I think a marsh scene with a low horizon and a large sky will be a good subject for this experiment. The sky can be done wet-in-wet and the marsh will give us the opportunity to use some drybrush. The step-by-step procedure is illustrated in the first demonstration in the final section of this book.

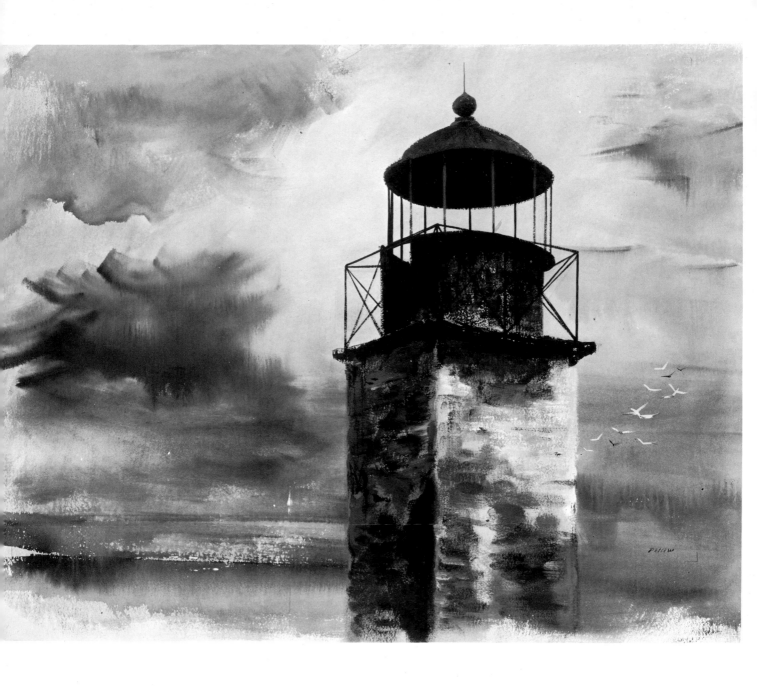

**Abandoned Light,** watercolor on paper, 21″ x 28″. Collection, Mr. and Mrs. George McDonald.

*This old lighthouse stood at the entrance to Huntington harbor on Long Island. It was a ruin when I painted it several years ago, and no doubt it has disappeared by now. It was a picturesque ruin, the ironwork of the upper part colored with rust, while the masonry bore the patina of years of exposure to the elements. It was dramatic in its starkness, yet it was somehow peaceful at the same time, like an old warrior resting in the sun. The day I made the sketch from which this was painted,* *the sky and sea were a brilliant blue and the foundations of the lighthouse were surrounded by almost white drifted sand. None of this appears in my finished picture. The sky and ocean are painted in warm grays— the sandy beach doesn't show at all. The lesson for the amateur to learn here is this: avoid painting the obvious if you want to lift your work above the commonplace. Could I have told the story of this old lighthouse any better by painting the whole structure? I don't think so.*

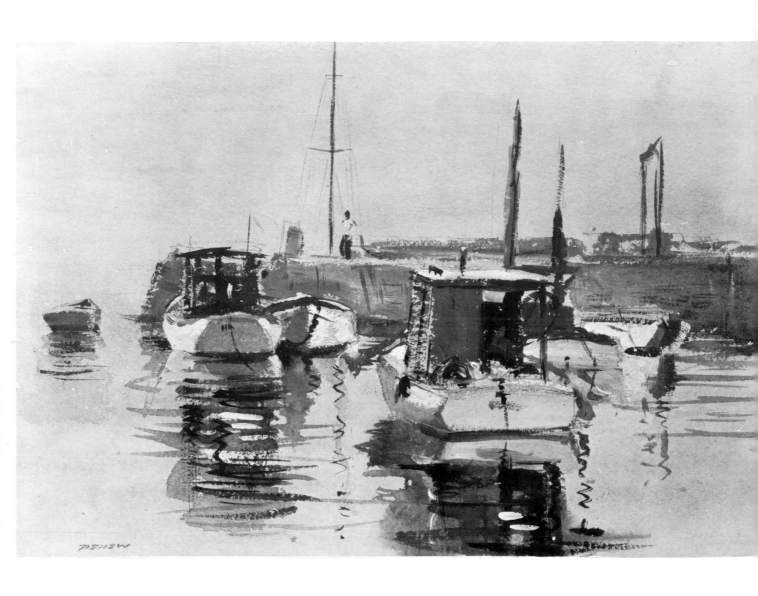

**Lobster Boats,** watercolor on paper, 7½" x 11".

*Whenever possible, I avoid the blue sky-blue water type of harbor picture. I prefer the fog and mist so often found along the New England coast in the early morning. This is a fairly good example, I think. It's painted in tones of warm gray. There's a suggestion of sunlight breaking through; this can be seen in the warm whites on the lightstruck sides of the boats and in parts of their reflections in the water. After lightly sketching the subject with an HB pencil, I coated the entire surface of the paper wtih a warm gray: a mixture of opaque white to which yellow ochre, cadmium red light,* *and Payne's gray were added in small quantities. This was thin enough to allow the pencil drawing to show through. It's been left untouched in the sky and in most of the water area. The stone jetty was next to go in, followed by the boats and their reflections. In the foreground boat, there's a touch of red at the water line and the little figure is wearing a yellow shirt. These are the only bright colors in an otherwise gray picture. It's an eighth sheet, painted in Rockport harbor about 8:00 A.M. on a September morning.*

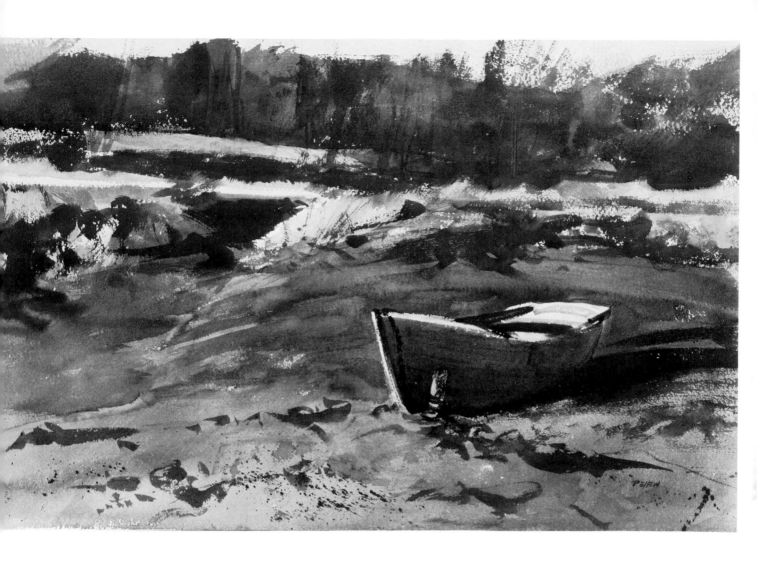

**On the Mud,** watercolor on paper, 15″ x 21″.

*Painted on a cold day late in the afternoon—note the long cast shadow from the boat. Early morning and late afternoon are the time of the long shadows and rich, deep color. Because of the rapidly changing light, I had to work fast, and that's the reason for the bold, simple brushwork that's really a kind of calligraphy (or short-hand) used to describe the character of the picture's various parts. For instance, look at the foreground. Those rapidly dashed in dark strokes and squiggles represent seaweed left on the mud by the retreating tide. Now, if there had been plenty of time, I might have been tempted to "work up" this interesting pattern of seaweed—but there wasn't, so I didn't, and I'm glad. Full speed ahead from left to right with a fully loaded brush—and that was it. I can usually tell if a brushstroke has been painted rapidly or slowly. John Singer Sargent's brushwork is marvelous—such speed. The late watercolors of Winslow Homer also contain bold, swift brushstrokes, well worth some study. Brushwork is the handwriting of the artist. Don't try to disguise it.*

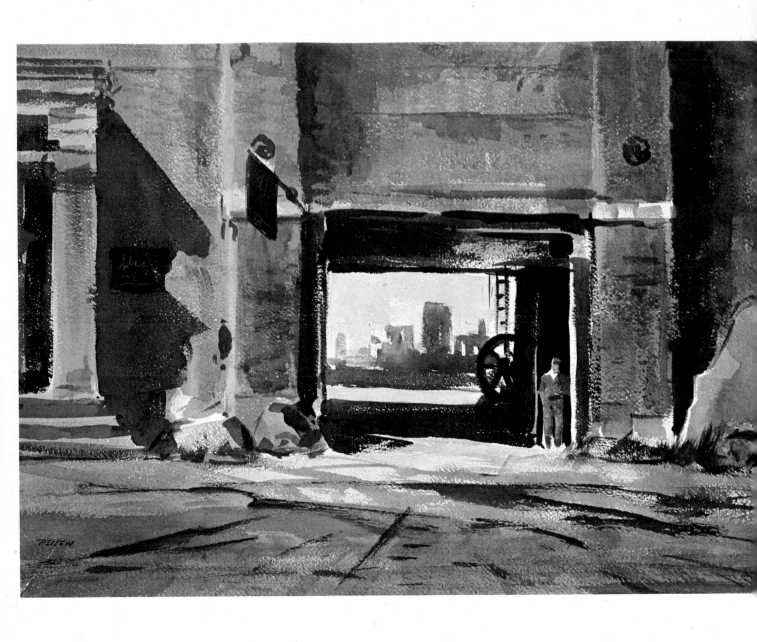

**Marble Works,** watercolor on paper, 20″ x 27″.

*Not long ago, I received a letter from an art student living in Long Island City, New York. He sent me a watercolor he'd painted from a magazine photograph. His reason for doing this, he wrote, was the fact that there was nothing to paint in his neighborhood. My reply must have shaken him up. I certainly hope it did. Before moving to Connecticut, I'd lived and painted in Long Island City for more than twenty years. I pointed out that he was surrounded with good subject matter. I'd painted hundreds of pictures within a radius of five miles of his home. The East River, Hell Gate, barges, tugboats, old factories, and riverside parks are just a few of the subjects to be found there. I have no patience with people who do not—or will not—see the world around them. They always seem to think that somewhere else is where they should be in order to paint something good. It ain't necessarily so.*

*Marble Works was painted in Long Island City: a colorful old building on the Long Island side of the East River. I like the open doorway, giving the composition depth, and the big, simple shapes and cast shadows that create an almost abstract pattern.*

# Watercolor Techniques

The watercolors that I admire most are the ones that are done straight off, without any fussing around; no washing out, lifting out, or any of the other devices used to pull a watercolor through from a bad start to a presentable finish. The traditional transparent technique is the most exciting for me, and the most difficult to do. I hear the soaking wet paper boys screaming from here—but it's true. I've worked in both techniques, I still do, and I know.

## Dry Paper vs. Wet

There's a crisp, luminous quality about a wash of color applied with a full brush to a good sheet of dry, white paper that just doesn't happen on paper that's been soaked. The latter often has a tired, heavy appearance. It's true that good, even great pictures can be painted in both techniques; but I still say that the watercolors I like best are the ones painted as directly and simply as possible.

In the wet-in-wet method, you have the accidents working for you: all those cute, colorful blots and runs that are so devastatingly decorative. When painting directly on the dry paper, you're on your own. All you have working for you are skill and experience, two things necessary if anything good is to result. But what a thrill when you do pull it off! Beautiful, luminous washes, with the white paper gleaming through all but a few of the darkest darks.

Good examples of watercolors painted directly on dry paper are works by John Singer Sargent and Winslow Homer; the early work in the medium by Andrew Wyeth; and watercolors by the contemporary, Ogden Pleissner.

## Warning: Watercolor Dries Lighter

One thing that must be learned—if the student is to work in this traditional manner—is the fact that watercolor dries much lighter in tone than it appears when wet. Nothing destroys luminosity and freshness more quickly than overworking in order to darken areas that have dried out too light.

You must try to put down the right value at once. Beginners should test their washes on scraps of paper, drying them in the sun if you're working outdoors, or under a lamp if you're inside.

If it becomes necessary to go over a wash when you're working on dry paper, then do so as rapidly as possible, being sure that the underwash is thoroughly dry. Once you've gone over a wash with another, don't go back into it. Leave it. To go back is to invite disaster.

## Preliminary Drawings

The first step is a clean, neat drawing. The type of watercolor we're considering cannot be done on a paper that has had its surface beaten to death with a soft pencil and eraser. I know of one fine contemporary painter who first makes his drawing on tracing paper. After all corrections are made, it's transferred to the clean watercolor paper. This is done by rubbing the back of the tracing sheet with a fairly soft pencil, fastening it in place with masking tape, then going over the drawing with a hard pencil. A 2H is generally used, although I find that the HB works well enough.

The method described above is too complicated for outdoor work; it's for work carried out in the studio. Outdoors, you must draw right on the paper. The best advice I can give the beginner who's anxious to sketch in the field with the direct dry paper approach is this: avoid complex subjects. Don't paint a house; paint the doorway. Not a harbor full of boats; just one boat.

## When in the Field, Work Small

Another thing about outdoor painting: use a small paper, a quarter sheet (11″ x 15″) or even an eighth sheet (7½″ x 11″). My painting, *Upper East River*, is an eighth sheet painted on the spot, as simply and directly as possible. I must have spent all of ten minutes on it. Call it a quickie if you like, but quickies are often the best things watercolor painters do. I wouldn't part with this little picture.

## Wet-in-Wet Method

Now let's get back to wet-in-wet before the champions of that method get too mad at me. I've stated that great works can be painted wet-in-wet. So they can. Turner used it. However, he painted in every known method. In fact, he invented most of them. I'm reminded of a remark once made by a painter friend while we were walking through a gallery of Turners: "Let's not linger here, Jack; he spoiled the business." A tongue in cheek statement, but it points up the fact that Turner can't be followed. He was a genius, a law unto himself.

I've already stated that I use the wet paper method only for studio work, never outdoors. This, then, is my procedure. The subject is lightly sketched

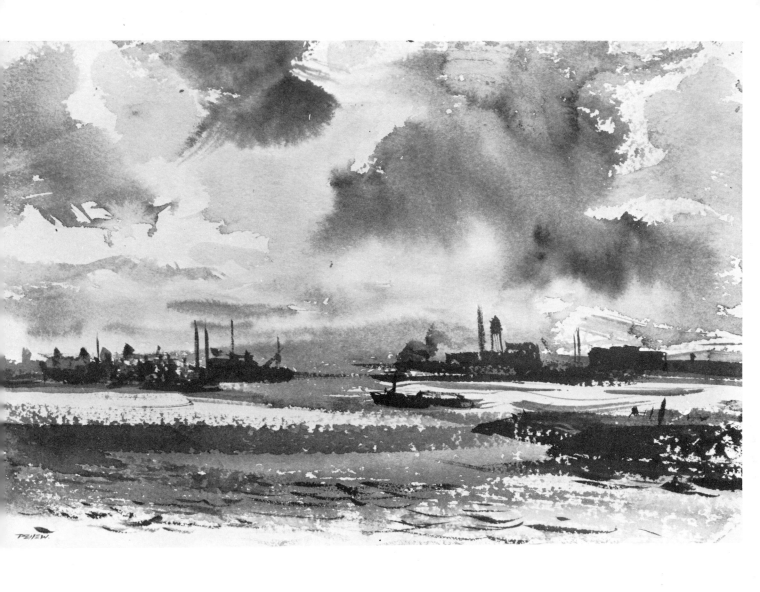

**Above Hell Gate,** watercolor on paper, 7½″ x 11″.

I've often said that the so-called "quickies" are the best things watercolor painters do. There's a spontaneity about these little pictures that's very difficult to achieve in paintings that are full sheet or larger. I think of them as a kind of shorthand note, put down at white heat with the brain and hand working together at full tilt. Of course, I mean the quickie painted outdoors, face-to-face with nature. The small picture carefully painted in the studio is something else again. The paint-ing above is an eighth sheet. It was painted on Randall's Island in New York's East River. The view is northeast toward Long Island Sound. I'd first painted a half sheet which turned out to be a dud because I'd worked too long on it, overdoing detail and creating muddy color washes. Starting over on the eighth sheet, I allowed myself ten minutes. The result is a little picture I've kept for fifteen years and I'm still not ready to part with it at any price.

on the dry paper with an HB pencil. I keep the drawing simple and the paper clean. If it's necessary to rest my hand on any part of the pencil work while I'm drawing, a scrap of paper is used to rest the hand upon. I sketch only the bare bones of the composition and leave the details to be added with the brush.

### Soaking the Paper

The next step is to run about a foot of water into the bathtub and thoroughly dunk the paper. A full sheet, if too large for the bathtub, can be folded (not creased) in half. I allow the paper to soak for about ten minutes. While this is taking place, a sheet of glass is placed on the drawing table and a clean towel is made ready near by. The paper is slowly lifted by two corners and the water is allowed to drain off. The sheet is folded in half again (remember, not creased), held by one hand, the other holding the towel to catch the drops as the paper is rushed to the drawing table and placed on the glass. The towel is now used to flatten the paper by pressing out (not rubbing) any air bubbles that occur. Surface water is blotted up and the painting is started.

### Use Plenty of Paint

When you're working in this technique, the all-important thing to remember is that paint will dry out much lighter in value than it appears when wet. Pick up plenty of paint on the brush when you're putting in what are to be the picture's darker tones. I usually start with what are to be the lightest parts of the composition; then I add the more definite washes and the darkest darks as the paper dries.

Wet-in-wet and the transparent wash on dry paper are the two most popular watercolor techniques. However, there are other ways—some of them quite interesting and all worth experimenting with.

### Opaque Watercolor Technique

Let's consider gouache (pronounced GOO-WASH) or opaque watercolor. The same medium is used in gouache as in watercolor paints, but gouache paints aren't transparent. White has been added to them by the manufacturer to make them opaque. Winsor & Newton make a fine gouache which is sold in tubes under the trade name of Designers Colors. Pelikan is another good brand. The student can also experiment with the opaque technique simply by using opaque white with regular watercolor paint. In gouache pictures, tinted papers can be used. Covering and half covering strokes can be quite effective on tinted or colored paper. Of course, if the picture is to have the quality of a good gouache, most of the paint application must be

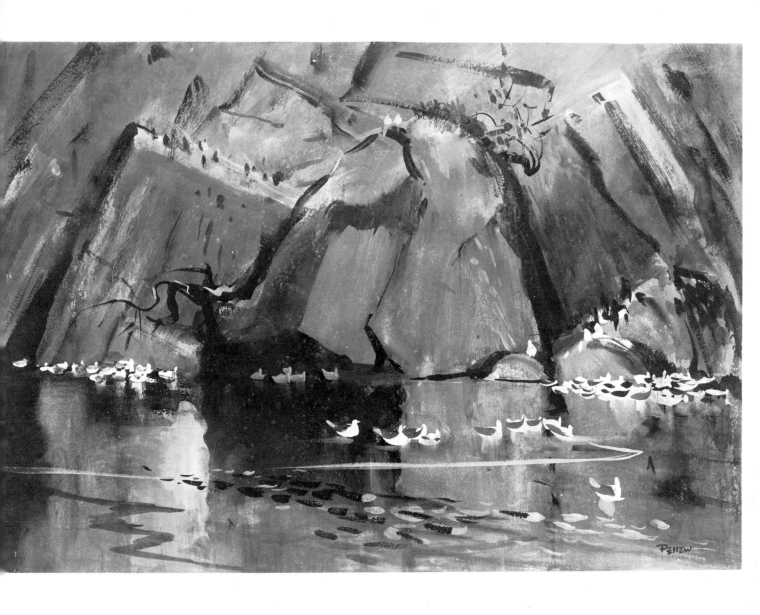

**Quarry Gulls,** opaque watercolor on paper, 20″ x 28″.

There are many old abandoned quarries on Cape Ann. It's a common sight to see a couple of hundred gulls resting on the fresh water with which a quarry is flooded. The massive gray granite walls, reflecting in the dark pool below, with the gray and white gulls creating intriguing patterns on its surface, are beautiful to see. It's a subject of interest to both the realist and the abstract painter. I think my picture belongs to that vague borderland between the two. I'd been thinking of the subject for some time, and one day, many miles from Cape Ann, I painted it from memory. That,

no doubt, accounts for its semi-abstract qualities. One of the good things about painting from memory is that so much is forgotten. I wasn't tempted to overdo the rock textures and detail because I could only recall the big shapes. Except for the gull in the center of the picture, the others have been indicated in what could be called calligraphy that merely describes their general shape and color. This holds true also of the water. Notice the horizontal lines which were used to establish the plane of the surface, as well as to break up the vertical lines of the rock reflections.

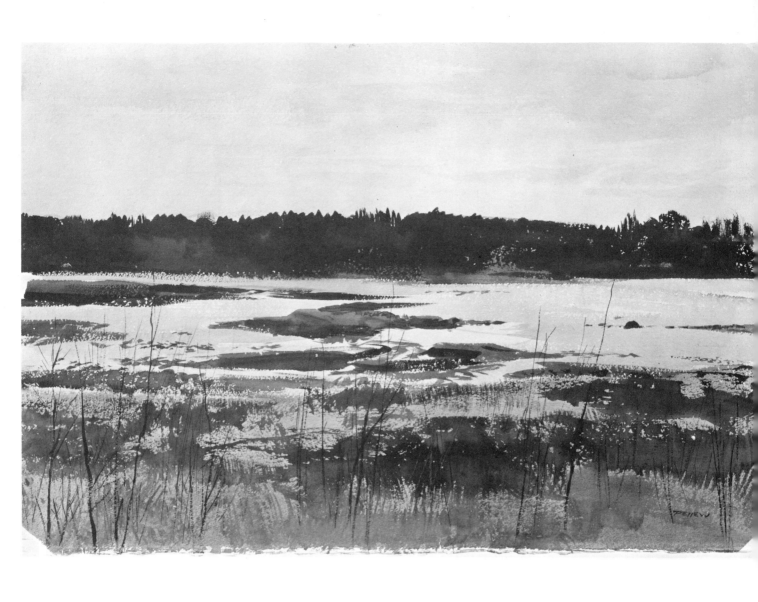

**Deer Island,** watercolor on paper, 15″ x 20″.

October among the salt marshes of coastal Maine is a delightful time of year. The warm colors of the marsh grass, contrasting with the dark greens of pine and fir, creates a scheme of color ready made for the watercolor painter. Driving down toward Stonington one autumn morning, I found this subject. Actually, it was no better than many I'd already passed and many others that were further on, but I had to stop somewhere. This is the country beloved of Sarah Orne Jewett, author of the American classic, The Country of the Pointed Firs. The spirit of that delightful book haunts this Maine peninsula at all times of the year. However, it comes across really strong during the golden days of autumn. On this particular morning, there was a pale gray sky, reflecting in the shallow water. The tide was low and there were areas of uncovered sand showing between patches of tall grass and weeds. The cool gray tones of sky and water, the dark greens of the distant trees, and the warm colors of foreground sand and rocks all combined to make a real "Down East" autumn color scheme.

**A Rockport Doorway,** watercolor on paper, 20" x 27".

*I love old houses and this one on South Street, Rockport, is a beauty. It's been spruced up since I painted it, and although it was the proper thing to do, it's not as interesting now as a painter's subject. I seldom paint a full sheet outdoors. However, this one was painted across the street on a sunny September morning. It's a happy picture, full of sunlight and shadows. I worked rapidly to capture the lighting effect before too much change took place. The picture was finished in just over an hour. Because of the need for rapid execution, a good deal of opaque color was used. The sun spots in the foreground, for instance, are mixtures of white with a touch of cadmium yellow light. The darkest darks could also be called opaque, as they were painted with pigment diluted just enough to make it flow from the brush. It's the final result that counts. I feel that I did get an impression of the day and the place. If there are opaque passages—who cares.*

opaque rather than transparent. Turner made good use of both blue and gray papers for gouache painting.

Here's another use for opaque white. I'm sure I'm not the inventor of this method. I believe I detect it in some of Turner's papers. (That man again!) Simply stated, it's this.

Mix a puddle of white gouache in a saucer. Add enough water to give it the consistency of light cream. Paint the mixture over the entire surface of the paper. It's best to use a large, flat brush for this. The mixture should be thin enough to allow the pencil drawing to show through. In other words, it's really a *transparent* wash of white, not an opaque, covering coat. The painting of the picture then proceeds with regular watercolor, painting right into the wet white. Beautiful soft sky effects can be obtained in this manner. I've used it for fog and atmospheric harbor scenes.

## The Influence of Your Painting Surface

The type of paper you use has a great deal to do with the kind of technique that's possible.

Rough paper is fine for drybrush. The brush skips over the paper's rough grain, touching only the high spots. With practice, all kinds of textures can be suggested with drybrush. The great danger here is in overdoing. I prefer the more subtle surface of cold pressed paper for drybrush and for most painting techniques.

Smooth paper, called hot pressed, isn't used often, but it's worth a try. However, the beginner should leave it until he has developed some speed in handling watercolor. Unless one works rapidly on smooth paper, hard edges develop and washes get out of control. Along with the disadvantages, there are some advantages. Because there are no shadows like those cast by the grain of rough paper, subtler color and greater luminosity are possible. Color is easily lifted from smooth paper; parts can be wetted with clean water and blotted with tissue; or the edge of a razor blade can be used to create lights in dark areas.

Watercolor on gesso works about the same as on smooth paper. Of course, the gesso you use should be acrylic gesso, which dries with a hard, smooth surface. If a rough paper is given a fairly thin coat of acrylic gesso, the watercolor painted upon it can be given great textural interest by the use of various tools to lift the wet paint. Razor blades, palette knives, and fingernails are most popular. Like drybrush, the temptation is to overdo.

## Paste Method

I may as well mention a very old technique that (as far as I know) no painter is using today. It's a tricky thing called the paste method. It can yield some unusual results. Cotman used it for a time and I've seen evidence of its

Paste method. *Mixing starch or library paste with watercolor is a very old technique. Using the paste method, it's possible to obtain sharp, crisp strokes that have the quality of transparency.*

use in pictures of the Victorian period. I must admit that I've never used it, so don't take this as a recommendation. However, I pass it on for what it's worth. Someone might give it a new twist and come up with a masterpiece or two.

The procedure is quite simple. Make about a half cup of flour paste by mixing some fine white flour with hot water. Let it be of a fairly thick consistency, but strain the mixture through cheesecloth to get the lumps out. Allow the mixture to cool. Pick up some paste on the brush and work it into the paint on the palette as you paint. Sharp, crisp strokes result. However, they have transparency and not the opaque quality of a stroke made with gouache. Water can be used for thinning; color washes in combination with definite brushstrokes seem to give the best results. White library paste can be used by those who don't want to bother making the flour kind.

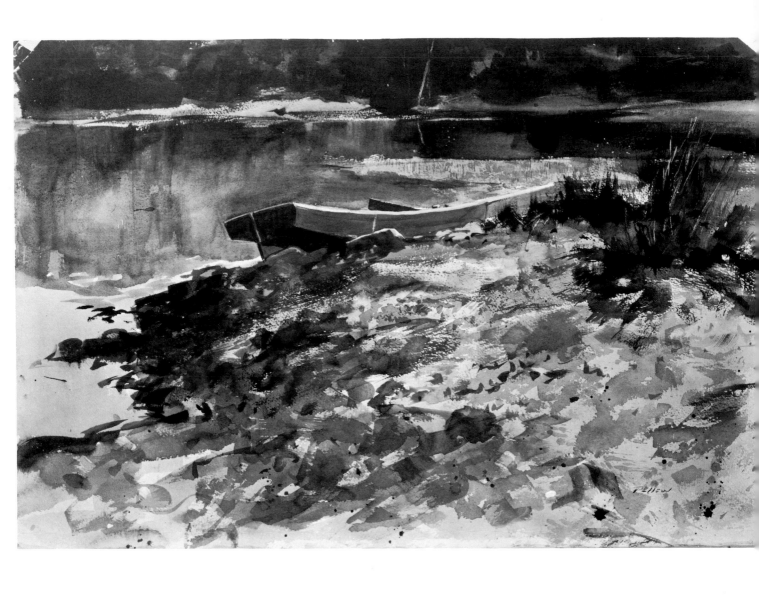

**The Red Boat No. 1,** watercolor on paper, 15″ x 20″.

*A sunny summer day along the Saugatuck River: the rocky river bank and calm water reflect the sky and dark green trees. Although the sky—with patches of blue showing through interesting cloud formations—was very tempting, I decided to sacrifice it in order to given the boat greater emphasis. The amateur painter often tries to say too much on one piece of paper, ending with a composition that has no single dominant point of interest—a picture lacking unity. Design is of the utmost importance, no matter how realistic your approach to the subject matter. In this painting, the eye moves from the foreground to the boat, is stopped by the dark patch of weeds at the right, then moves into the picture by way of the sunlit area of marsh grass just above the boat, and on to the sunny, far bank of the river. This kind of spatial arrangement doesn't happen by accident; the experienced landscape painter does it instinctively. The amateur better give this some thought.*

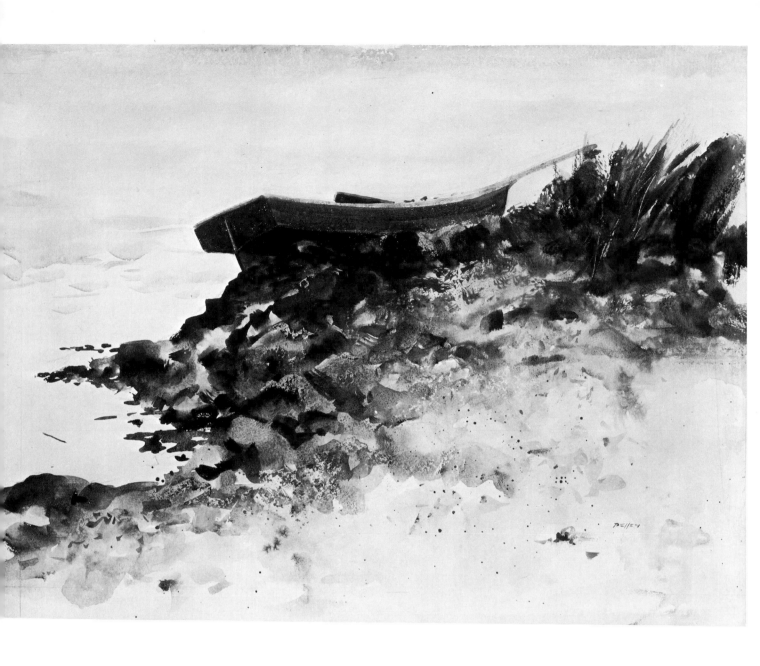

**The Red Boat No. 2,** watercolor on paper, 15″ x 20″.

*I sometimes redo one of my outdoor paintings in the studio if I think I can improve it in some way. Often a good picture can be made from a poor one—especially when the on-the-spot picture suffers from overwork. It's easier to simplify in the studio than it is in the field. There aren't so many distractions in the studio, while nature can be bewildering at times. This picture was painted from* The Red Boat No. 1, *and I think it's a good lesson in simplification. The same boat is in the same position; the weeds and the rocky bank remain; but the background of river and distant shore has been omitted. This is true also of the right foreground, where much of the detail has been eliminated. The eye moves into the picture from the left foreground and follows the rocky bank to the boat, which is now the dominant point of interest. There's no competition from any other elements. Learn to appreciate the strength and beauty of simplicity. It's difficult—but so necessary—to learn.*

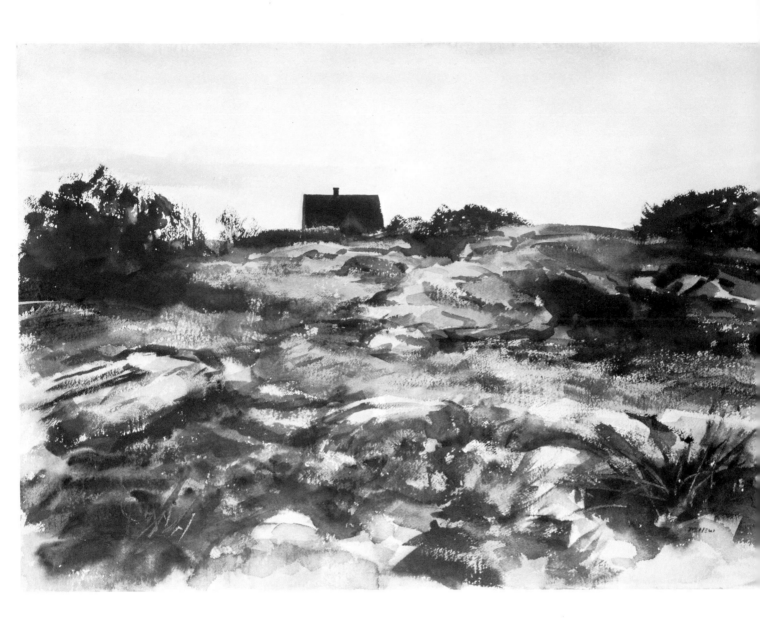

**The House on the Headland,** watercolor on paper, 22″ x 30″.

*A rocky headland with scrubby bushes, sparse grass between the outcroppings of granite, and a house with a steep pitch to the roof: that describes northern New England and this picture. It's a subject that's been done often, perhaps too often, in recent years. However, don't let me discourage you. It's not what you paint but how you paint it that's important. In the picture above, I've tried to convey the illusion that beyond the house lies the sea. Even though it cannot be seen, there should be the feeling that it's there. The composition, though simple, was given some thought. If the house and the dark bushes hadn't been carefully proportioned and positioned, the result might have been a monotonous lineup. Note that the house is to the left of center and the bushes, though similar in shape, are all different in size. Except for the chimney, I used a 1″ flat sable.*

## Beware of Gadgets

That ends my suggestions about various watercolor techniques. Before closing this chapter, however, I do want to say a few prejudiced words on the use of gadgets.

Actually, all that you need to paint a watercolor are a couple of brushes. That's true. Just two brushes and a lot of guts.

But there are painters, not just beginners, who fall in love with gadgets. There are all manner of things used to torture the wet paint—rubber squeegees and sink stoppers, pieces of wood whittled to various widths and shapes, to name just a few. The trouble is that their use produces a tricky effect that may be acceptable in one picture or even two, but the gadgeteer gets carried away and repeats the trick over and over until it becomes a mannerism. It's like watching acrobats: you admire the skill, but enough is definitely enough.

A razor blade and the painter's fingernails are all that you should need beyond a brush or two.

My pet peeve is the use of rubber cement or some liquid masking fluid to stop out areas where white paper is to be "saved." For beginners who aren't familiar with the practice, I'll explain. Suppose your foreground is made up of tall grass and weeds. To paint background color around each individual blade of grass or weed stem would be impossible for most of us. So, having roughly indicated the foreground with pencil, the painter paints the grass and weeds with masking fluid or rubber cement. When dry, the background is painted right over it. When the wash is dry, the parts previously painted with "mask" or rubber cement can be rubbed off, leaving clean, white paper for the blades of grass, ready to tint any color the artist desires.

Now, isn't that great? Well, it *would* be if it worked; but it doesn't. Grass treated in this manner never has the appearance of real grass. It just looks like a lot of stiff wires. Sorry, but I don't think masking fluid has a place in realistic painting intended as fine art. It was used originally by commercial artists and I'm afraid it still looks commercial. The only time I've seen it used with good effect is in abstract painting; there it can be used to stop out an area or shape that isn't intended to be realistic. Let's forget it and go outside to see what the landscape really looks like—without benefit of masking fluid.

**Ghost Town,** watercolor on paper, 20″ x 28″.

*This should prove that you don't have to paint the whole street to create an interesting street scene. I didn't even paint the complete facade of the old abandoned building, yet I think it tells the story well enough. I found this subject in St. Elmo, Colorado. I was there conducting a workshop for artists and students. We explored many of the ghost towns and old mining camps. The gold mines stopped working long ago, but the boarded up houses, general stores, and saloons are a gold mine for the artist who who has a feeling for that kind of material. Although the noon hour isn't my favorite time for painting, in this case it worked well. The sun being almost directly overhead, the front of the building was in shadow, with bright light on the board sidewalk and road. The tattered poster to the right of the door is balanced by the two bright lights on the steps. I used a good deal of drybrush because I feel that its rough texture lends itself to the character of the place. Some of the detail in the foreground was suggested with spatter, obtained by tapping a brush loaded with paint on the handle of another brush, causing the paint to spatter in spots on the paper.*

# Observing Landscape

When the beginning watercolorist first goes to nature to try his hand at landscapes, what should he look for?

Let me tell you first what he should *not* look for. He should *not* look for a subject that reminds him of the subjects painted by his favorite artist. There are a lot of people out today looking for ready-made Wyeths. To them, I can only say that the best Wyeths are painted by Wyeth.

The thing to do, then, is to clear your mind of all preconceived notions of what a landscape subject should be. Walk around and when something stops you that looks interesting for itself alone—and not for what it reminds you of—that's your subject. It may be an effect of sunlight and shadow or a pattern of shapes. Whatever it is, it's yours. Give it all you've got and don't be too disappointed when you fall short of what you expected to produce. We all do.

Don't feel that you must have what is called a "view," a picture complete with foreground, middle distance, and distance. Keep your eyes open for things under your nose. You could be passing up a real gem. (I deal more fully with the closeup in Chapter 10.)

## Trees

Some things in nature are so familiar that we take them for granted. Trees, for instance. Most of us see them every day; yet the beginner in landscape painting gives so little thought to the tree that he ends by painting his trees as little green balls on a stick.

I've always enjoyed painting trees. They display such variety throughout the year—so many changes of color and pattern. The painter needn't know as much about trees as the forester does, but he should be familiar with the different types. I think that the best way for an art student to soak up knowledge of trees is to fill some sketchbooks with drawings, in pencil or pen, of all kinds of trees.

You'll never be able to paint them convincingly in a spontaneous watercolor technique unless you've first learned the secrets of their anatomy.

Tree exercise: Step 1. *When painting foliage in watercolor, the beginner often makes the mistake of trying to render individual leaves. I suggest that you learn to paint the mass, merely indicating the detail. After sketching the tree in pencil, paint the foliage with a big, flat wash. This will be your lightest value. If the tree is against the sky, don't make this wash too light in value.*

Tree exercise: Step 2. *Into the first wash (while it's still wet) put the darker shadow tone and allow it to blend, wet-in-wet, with the first wash. Remember that the light comes from above. Let the upper part of the foliage retain the light tone, with the darker tone toward the underside.*

Tree exercise: Step 3. *When the first two washes have dried, add a little drybrush for textural interest. Paint the branches and trunk. The tree is finished. Of course, all trees cannot be painted as simply as this, but it's a good way to start. I suggest that you practice with one color, perhaps burnt umber.*

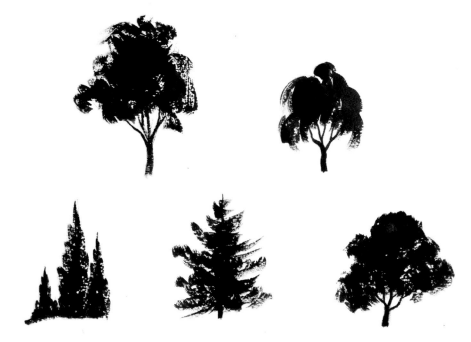

Tree silhouettes. *Become familiar with as many tree characteristics as possible. A good way to do this is to make silhouette drawings as shown here. The silhouette reveals the character of the different types. From left to right, I've shown elm, willow, fir, spruce, and apple.*

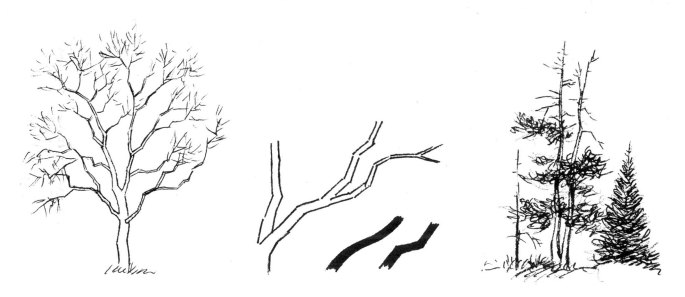

*Trees. Sketch the bare trees in winter to learn something of their anatomy (left). You needn't draw every individual twig—just the character of the mass. Draw the branches (center) with short, angular strokes, not with long, flowing, curved lines. Fill sketch books with tree sketches in pencil or pen. The drawing at right was made with a Pentel pen. You learn to draw by drawing and you learn about trees by drawing them.*

When you sketch trees, consider the big, over-all shape before you look at the detail. This is just as true of bare trees as it is of those in full foliage. The over-all shape of the elm is quite different from that of the willow, and both are not at all like the beech or maple. These are all deciduous. I haven't even touched on the great variety found among the conifers.

So you see that trees are not just blobs of green in summer or an upright pole with some stiff branches at right angles in winter. Trees are lovely things. I could spend the rest of my life painting the trees in the patch of woods behind my studio.

Listen to what the great American poet, Walt Whitman, had to say about trees: "Why are there trees I never walk under but large and melodious thoughts descend upon me? I think they hang there winter and summer on those trees and always drop fruit as I pass."

To help you learn more about trees, I've illustrated the more common tree types, and how to sketch them with pen or brush.

## Brooks and Ponds

What of brooks and ponds? The landscape student has to deal with them sooner or later. One sure way to get a cornball calendar picture is to paint a pond reflecting the landscape. When on location, I've often kidded my students when they display rather too much enthusiasm for those lovely reflections. Of course they *can* be painted. Think of Claude Monet and his

  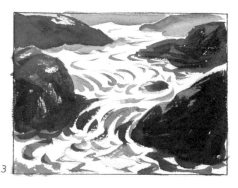

Running water: Step 1. *When painting a brook or a mountain stream, I've always found it best to use brushstrokes that follow the action or direction taken by the flowing water. To point this up, I've placed arrows on my pencil drawing.*

Running water: Step 2. *Without the arrows and with the first light washes put in, the watercolor of a swiftly flowing stream would look like this.*

Running water: Step 3. *Here is the finished picture of water flowing rapidly between and over rocks. The brushstrokes in the water are a form of calligraphy used to describe the water's action.*

Weeds and grass. *At left, you see a dark mass with a variety of drybrush edges. These were obtained by pressing a No. 9 round brush on the palette to flatten and spread it, then using it with a swift upward stroke. For the series of dots at the top, I patted the brush onto the paper, holding it parallel to the paper's surface. Before the dark wash of paint seen at the left was dry, I used my fingernail to scratch in the suggestion of grass shown at right. I think the fingernail produces a less mechanical mark than a razor blade or a knife.*

lily pond; there's the answer—the how-to-do-it. Paint the reflections, but don't divide the picture space equally between landscape and reflections. If you do, you get a picture that looks just as well upside down as it does rightside up; but no matter how you look at it, you have *two* pictures on one sheet of paper.

Lakes and ponds get their color from the sky and reflections of nearby trees, houses, hills, etc. Reflections are mostly the color of what's being reflected. Don't have a yellow-green tree with a blue reflection. Remember that the water acts as a mirror. In very shallow ponds, the character of the bottom will also have some influence on the color of the water.

When they paint streams or brooks, the mistake most often made by students is to take in too much. It's best to settle for two or three rocks, some turbulent water, or some water that's quiet and slow moving, with a bit of the bank and little or no landscape.

The foam that swirls around the rocks in a mountain stream is often indicated by leaving pure white paper. This sometimes works, but more often it looks too cold. I think it's best to warm the lights with a pale wash of yellow ochre. Short, crisp brushstrokes are best used to capture the action of this fast moving water. On the other hand, long horizontal strokes can be used to establish the plane and suggest the character of a body of still water.

## Grasses and Weeds

Grasses, weeds, and similar growing things are always best when "suggested" in watercolor, rather than painted out in detail. A variety of drybrush strokes and your fingernail will provide the necessary textures. Students who make careful drawings of grasses and weeds in their sketchbooks will have greater confidence than the non-sketcher when it comes to painting them rapidly into their watercolors.

When using drybrush in grassy foregrounds or foliage areas, beware of overdoing it. So much of the limpid charm of watercolor is lost when drybrush is overworked.

## Sunshine and Shadow

The sun is the source of light. The painter must keep its direction in mind while painting. Light models form with light and shade. Without this tonal pattern, there can be no illusion of solidity. A house, for instance, appears more solid on a sunny day, when there are crisp planes of light and shadow, than on a day when it's enveloped in fog, and light and shadow are minimized.

It seems to me that the painter has only two ways to suggest the feeling of sunlight and shadow in his picture. He can paint a high keyed picture, filled with light everywhere, or he can make the darks quite dark and make

the lights more brilliant by contrast. The second method is the usual way. However, the shadow areas must be kept luminous. They're never as dark in value as they appear at first glance, and are indeed never as dark as the camera records them. That's why, when painting from a photograph, it's necessary to avoid getting trapped by photographic values.

Outdoor light is reflected into the cast shadows from the sky. This is especially true of shadows cast upon the ground. How can such a shadow be painted dark enough in value without being muddy and lacking in luminosity? First of all, keep in mind that it's not as dark as it seems to be. Keep the sunlit areas near it bright for contrast. Now paint the shadow with a superimposed wash.

Let's suppose we're concerned with the shadow of a house, cast upon a sunny, green lawn. Sunlight being warm, we paint the grass with a nice bright yellow-green, say a mixture of gamboge and a touch of thalo blue. This is allowed to dry—really dry. While we're waiting, a puddle of the blue is prepared. Now we're ready. With as large a brush as we can handle in comfort, fully loaded, the shadow tone is painted in right over the yellow-green. If this is done rapidly and not gone back into, the undertone won't pick up. It's the green showing through the blue, and the white paper gleaming through both, that give the shadow its luminous transparency.

Scrubbing into and picking up undertones seems to be the most common cause of muddy, tired shadow areas in the work of amateurs.

The man who wrote that he'd never seen a purple cow may have been a poet, but he'd never looked at nature with the eyes of a landscape painter. A white cow, seen in silhouette against a sunset sky, could easily be purple. In fact, it would be strange for the cow to be anything but purple.

So keep the shadows cool in color and luminous in quality. In contrast, let the lights be warm.

**Mood**

How does one create mood in a picture? I really don't know. I can only tell you what I *think* does it. We say that a certain picture has a happy mood. That's usually because it contains bright, clean color and is painted in a fairly high key. On the other hand, we call a painting somber if it has been painted in a low key with little value contrast.

Then there's what's called the delicate or feminine mood—a very high keyed picture with pale, pleasing color and close values.

Subject matter can also play a part in creating mood. A colorful bouquet of flowers is gayer in mood than a dead tree. An abandoned house is sad, while one with well kept grounds and children playing in the yard creates a quite different emotion in the viewer.

It's been said that some of my paintings are moody. Perhaps it's my Celtic background. But I don't think anyone should strive to put mood into a picture. Like originality, if it's there, it will come out.

Wet-in-wet sky: Step 1. *Wet the sky area with clean water, using a flat brush. Wait until the shine is off the surface; then rapidly paint in the cloud pattern. The paper must be damp enough to prevent hard edges from forming.*

Wet-in-wet sky: Step 2. *You can now paint a second color into the first while it's still wet. Remember that with each step your sky gets progressively darker.*

Wet-in-wet sky: Step 3. *You now add the final darks. Each step must be taken while the paper is quite damp in order to avoid hard edges. Notice the sharp edge of the mountains in the foreground, painted after the paper had dried.*

Sky on dry paper: Step 1. *Lightly pencil in the cloud formation and rapidly paint the blue sky around it. Dip your brush in water, squeeze it out between finger and thumb and soften some of the edges.*

Sky on dry paper: Step 2. *Mix a tone for the shadowed part of the clouds. Make the mixture of two colors only: You might try thalo blue and burnt umber or Payne's gray and cadmium red. Paint in the shadow tone. Note how the clouds diminish in size toward the horizon—this is called the perspective of the sky.*

Sky on dry paper: Step 3. *As a rule, the sky is the lightest part of a landscape painting. However, there are times when, for dramatic impact, you may want to place emphasis on the cloud formation. In step 3, I've simply darkened the value of the blue and the clouds' shadow side, creating greater contrast between the clouds' bright, sunlit edges and the sky's darker parts. I usually settle for the tonal values shown in step 2. Remember, the sky is the source of light.*

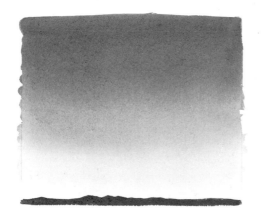

A clear sky. *This is simply a graded wash. You start at the top of the paper with plenty of paint and a large, flat brush. You work downward with overlapping horizontal strokes, adding water to the brush as you go. When correctly done, there should be a gradual change from dark at the zenith to light at the horizon. It takes practice to do it without leaving streaks. Some painters like to wet the sky area first with clean water.*

## Skies

Now let's look up at the sky. I'm afraid that beginners in landscape painting don't look at it enough. They have a tendency to regard the sky as a backdrop, just hung up behind the landscape. It's far from being that.

It's deep space. If clouds are present, they have perspective and aren't just round or oval patches of white on a flat field of blue. You don't have to be a meteorologist, but if you're going to paint landscapes, you should be familiar with the characteristics of the different types of clouds. You should also remember that they appear to diminish in size as they approach the horizon.

When we look up, we're looking through layers of atmosphere that contain all manner of particles, dust, and smoke. These layers are thicker when we look toward the horizon because we're now looking through the accumulated thickness of miles of atmosphere. It's this that creates the change of values from foreground to horizon.

## No Rules for Composition

Whole books have been written on the subject of composition. I've never read any of them. It's always seemed to me that composition is a matter of good taste. It's another word for design—an arrangement of shapes within a given space. Of course, it's a very important part of picture making. But can it be taught? I doubt it. There are some rules that everyone learns sooner or later, but even they can be broken by a painter of originality.

The only rule that has ever made sense to me is one that was written by Birge Harrison in his book on landscape painting. Here are those words, put down at the turn of the century by an American landscape painter: "Don't try to say two things on one canvas."

Any motif that's worth painting must have a central point of interest. Concentrate on that and sacrifice everything else to it. If there chances to be another attractive feature in the same subject, ruthlessly suppress it, in order that the one thing which you have to say may be said strongly.

The only other compositional rule I've ever given any thought to· is the one that warns against dividing the space through dead center. I tell students that landscapes compose best with the horizon or eye level *well above* or *well below* the center of the picture space. But it's a rule I often break.

So I repeat, I don't think composition can be taught. I think a feeling for design is born with some people; others acquire it, to some extent, through study of past tradition. In the end, it's simply a matter of good taste.

My rather smug remark about not having read any books on composition doesn't mean that I don't give the subject considerable thought when I start a picture. But my compositional habits have been formed from the study of good paintings by the masters, rather than from books. I study reproductions of works by painters I admire and also go to museums to look at originals.

## Planning the Abstract Pattern

I continually point out the importance of the abstract pattern to my students. Sometimes I'm asked what I mean by abstract pattern. I'll explain . . .

Try to imagine a realistic painting of a landscape, one with lots of detail. Now think of it with all the detail taken out. For instance, a tree—upon which you could see a suggestion of leaves and an indication of light and shade—becomes a flat shape, representing the foliage area. Think of the rest of the picture in the same way. What do you have left? Why the abstract pattern of course: a pattern of flat shapes.

Now the success of your picture depends on how well the pattern is designed. If it's poorly put together, color won't save it; nor will tricky brushwork. The size and shape of the big masses, and how they relate to each other, are of the utmost importance. If they're all too equal in size, you'll have a static composition. If the picture space has been filled with too many little shapes, the result will be spotty and confusing.

Remember, it's not only the shapes of your main elements, it's also the shapes of the in-between or negative areas. For instance, think of the space between the edge of a house and the edge of the paper. To leave a narrow little strip is a mistake. So you move the house further in—or you run it right out of the picture and cut the house off midway.

The light and dark pattern must also be considered. Suppose the tree we've mentioned forms a large, dark mass on the left side of the paper. You'll need a balancing dark somewhere on the other side; it can be small because a small dark can balance a large one. If your main shapes aren't too alike in size, and your light and dark areas are well designed and balanced, chances are you'll have a good abstract pattern or composition.

How do you learn? By looking at good pictures and by trial and error.

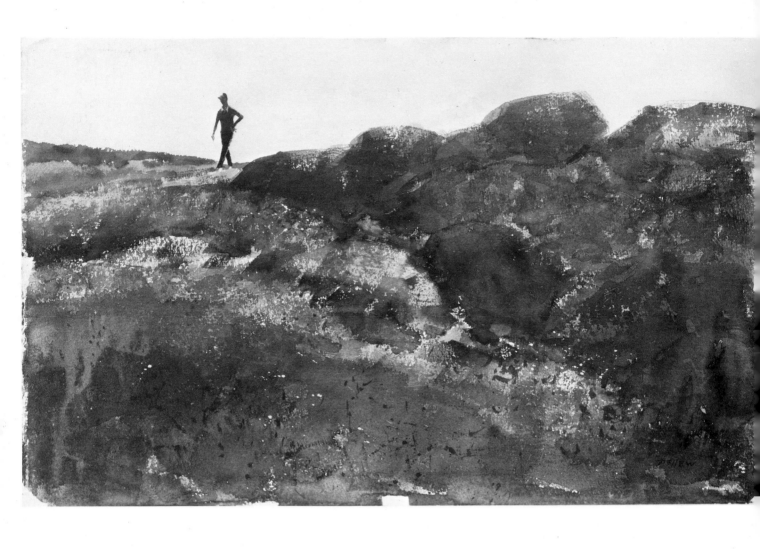

**Walking Woman,** watercolor on paper, 15″ x 20″.

*The composition of this picture is somewhat like* One on the Rocks. *There's the same small figure against the sky and the same large group of rocks. Although the compositions are similar, the color scheme of each is actually quite different. In* One on the Rocks, *there are the tawny, ochre rocks of Cape Ann, Massachusetts. In the above, we see the gray, lichen covered rocks of Cornwall, England. The grass area to the left of the rock formation is quite bright in color. It's made up of a variety of greens, obtained with mixtures of thalo blue, gamboge yellow, and raw sienna. The figure is wearing a red sweater with dark blue slacks. The head is a simple silhouette against the sky. The distant land on the horizon is quite cool in color and lighter in value than it appears in this black and white reproduction. The picture was painted from light to dark on dry paper, with the figure going in last. Drybrush textures can be seen in many parts of both rocks and grass. These textures were added when the underpainting had dried. To get them I used a 1″ flat oxhair brush, holding its side almost parallel to the surface of the paper —and a fast stroke, of course. The lady that you see on the horizon is Elsie Pellew, most certainly a walking woman if there ever was one.*

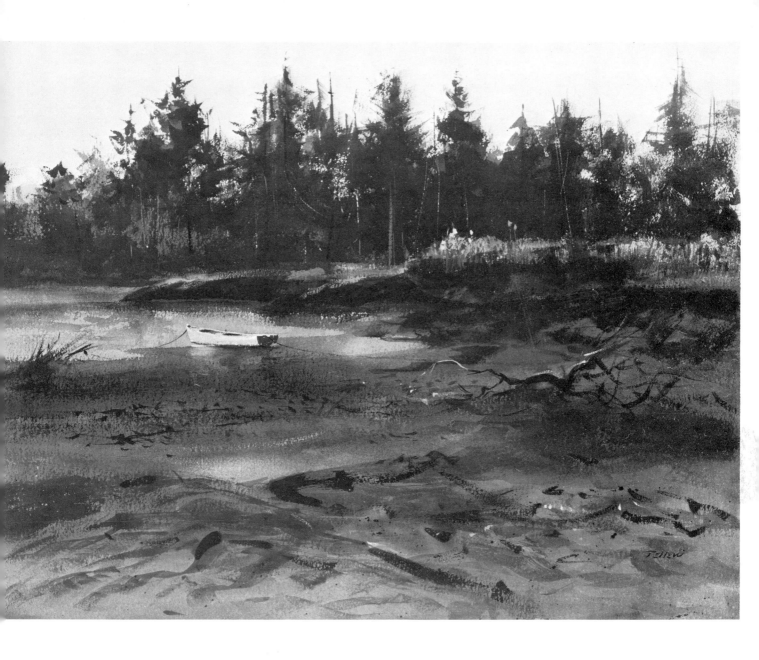

**Beyond the Pines the Sea,** watercolor on paper, 22″ x 30″.

*Asked to describe the technique of this painting, I'd have to say that it's mostly opaque. True, there are some transparent passages and the sky is painted with a pale, transparent wash, but the overall effect is like gouache in treatment. I wanted a dramatic mood, one that would convey the somber character of the place as seen in the low light of late afternoon. I think I chose the right technique. It seems to me that the traditional transparent method is best suited to pictures in a high key. When used for dark, low toned painting, the color washes become dull and muddy. I'm not a purist. I felt* *that opaque color was necessary here, so I used it. After my sky wash was dry, I painted in the dark pine trees, using a mixture of Payne's gray and raw sienna. Note the swiftly painted drybrush edges. The dark tone of the bank below the trees was then put in, using the same mixture. The muddy shore was next; I used a semi-opaque mixture of burnt umber, Payne's gray, and white. The dark details were painted into this before it was quite dry. The light part of the boat is white paper with a little drybrush. For the lightstruck bank below the trees, I used yellow ochre, raw sienna, and white.*

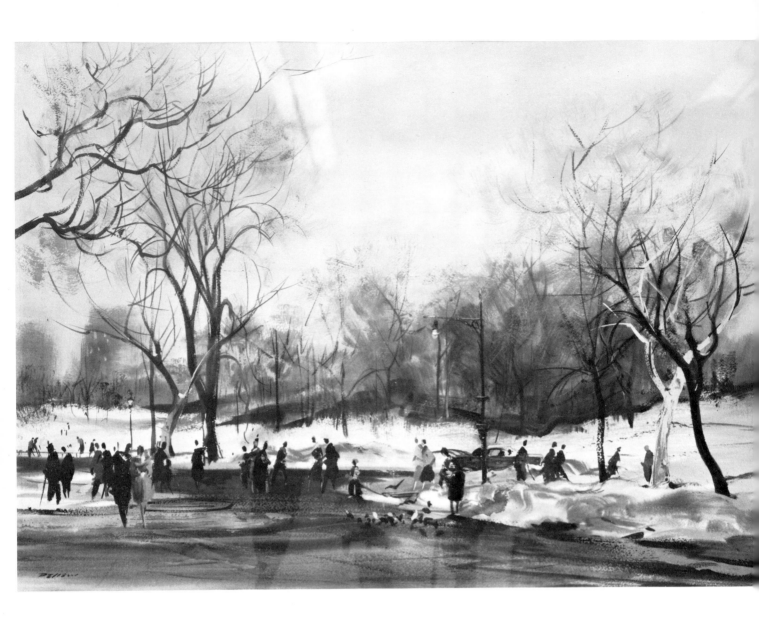

**Central Park, Winter,** watercolor on paper, 20″ x 27″. Collection, W. B. Conner Foundation.

*Very few of my New York City pictures are winter scenes. Most of the pencil sketches they were painted from were done in summer and fall, when it was pleasant to sit on a bench in the park and watch the strollers. However, one cold winter day on Fifth Avenue, just above the Plaza, I saw this interesting pattern of lights and darks. I guess that's how I first see a subject—as a light and dark abstract pattern. Amateur painters get too interested in things for what they are in themselves,* *rather than as part of a whole scene. That's why many of their paintings seem to be made up of separate parts. Their pictures lack the quality we call oneness. Opaque as well as transparent washes were used in painting this scene. The sky, the distant trees, the snow, and the road were all painted into a wet undercoat of opaque white. The foreground trees and the figures were put in after the rest had dried. The picture is a gray and white color scheme with touches of bright color for the clothing.*

74

# Painting the Four Seasons

There are painters who seem to use the same color scheme for every picture they paint. They indicate winter by leaving a generous amount of white paper and bare tree branches, but otherwise their color is the same for all seasons. I don't mean to imply that a watercolor needs to be brilliant in color to be good. A good painting is a good painting no matter what colors are used. However, there are vast differences in the colors of the seasons. Why not try to express them?

The painters I have in mind, if they happen to be teachers, often pass the monotony of their palettes on to their students. When working on art juries, I've often heard the remark, "That's one of So-and-So's students," as a picture passes in review. An imitation of the teacher's style *may* be the giveaway —but more often it's the color. The instructor has insisted on the student using the teacher's own palette of colors.

I've already listed the ten colors I carry in my paintbox for outdoor work. I may use three or four, or I may use all ten, but my intention is *not* to come up with a typical Pellew color scheme. I'd rather produce a color range that creates an illusion of the season and the mood of the day. I think it's possible to do this and still have the work identifiable as my own. So, students, beware of falling into the trap of color repetition, which becomes monotonous to the viewer when several of your pictures are seen at the same time.

"My choice of colors does not rest on any scientific theory; it is based on observation, on feeling, on the very nature of each experience . . ." says Henri Matisse.

## Spring Colors

Now let's take the seasons one by one, starting with spring. When I think of that lovely season of the year, the colors that come to mind are tender yellow-greens, the reds of tree buds as yet unburst, and the subtle violets of the twigs as yet uncovered by new foliage. However, keep in mind that many of the colors in nature are grays—warm and cool grays—and these are present at all seasons.

The yellow-greens of spring are best mixed with cadmium yellow pale (gamboge is too warm) and a touch of thalo blue. For those red toned unopened buds that cast a blush over the treetops in early spring, alizarin crimson can be used; it can be warmed with a little burnt sienna or cooled with some blue.

Violets can be purchased in tube colors: Winsor violet, thalo violet, cobalt violet, and mauve. But I prefer to mix my own, using mixtures of alizarin crimson and thalo blue.

Colors can be grayed by adding their complementary. For instance, you can add blue to orange, red to green, and violet to yellow. Many grays can be obtained with mixtures of warm and cool colors, such as burnt umber (warm) and thalo blue (cool); I find that this particular mixture serves quite well for almost all the grays I use.

## Summer Colors

The color I associate with summer is the rich green of trees in full foliage—a green that's quite warm in its sunlit parts, cool and luminous in the shadows.

I never carry tube greens. My favorite mixing color for summer greens is raw sienna. In fact, I couldn't get along without that color at *any* season. Mixed with thalo blue, it makes a deep olive toned green, a beautiful color for rendering a foliage mass seen against the sky. An even deeper olive tone can be obtained with a mixture of burnt sienna and thalo blue.

When I paint a large area of summer foliage, I usually paint the warm tone first, leaving some drybrush texture for sparkle (to be toned later). Then I paint in the shadow areas. These are sometimes done with a wash of blue only. Of course, it's a transparent wash, allowing the green underwash to gleam through. If the shadows become opaque, luminosity is destroyed.

Gamboge is a yellow I find very useful for mixing greens. It's warmer and less opaque than cadmium yellow. Gamboge, with the smallest touch of thalo blue, makes a brilliant yellow-green.

When painting trees in full foliage, remember not to make them too solid in appearance; let the sky come through here and there. After all, trees are made up of leaves, not rock. Harvey Dunn used to tell his students, "Leave big holes for the big birds and little holes for the little birds."

There's often a haze in the summer atmosphere, not present at high altitudes (Colorado for instance), but certainly present along the shores of the eastern United States, where I live. This haze causes the tonal values to appear cooler, lighter, and grayer toward the horizon. To cool the color, you add blue; to lighten the value, you add water.

To paint a summer landscape that's sunny in character, there must be a juxtaposition of both warm and cool color—warm in the light and cool in the shadows. The shadows should be kept simple in treatment, while details are put into lights.

**Autumn,** watercolor on paper, 15″ x 20″.

*When this picture was exhibited in a one man show held at the Grand Central Galleries, one of the New York critics called it "skillful." It was difficult to tell if he intended it for a compliment or not. I think this a good place to quote a couple of lines I came upon in the memoirs of the English author V. S. Pritchett: "The sight of skill and of traditional expertness is irresistible to me." Well, that goes for me too, so I'll consider the critic's remark complimentary, even if he didn't. Au-tumn among the coastal salt marshes is a beautiful time of year. The trees have lost some of their foliage, re-vealing the anatomy of their branches; what's left is burnt sienna and dark brown. The marsh grass is a golden ochre and a warm pink color in some areas. The distance is hazy and blue. The sky in this picture was painted into a thin coat of white to which a little yellow ochre was added. When dry, the trees were painted over it. Note how drybrush was used to suggest foliage.*

**The Sound of Birds,** watercolor on paper, 21″ x 28″.

This picture was painted as a demonstration for the Hudson Valley Art Association. Sometimes you do get a lucky one. If you've seen my book on acrylics, you'll no doubt recognize the figure. I used the same drawing for the figure in Return of the Native, reproduced in that book. The landscape part of this painting is from one of a series of drybrush drawings I made in New Brunswick, Canada. I think it has a feeling of the north country. Without the figure which provides a balance for the tree mass, the composition would be one-sided and too heavy on the right. Remember that a big mass can be balanced by a much smaller one. Notice the simplicity of my foreground. Don't fill foregrounds full of finicky detail—you just make it difficult for the viewer to enter your picture. When you look at nature, you don't see what's at your feet in sharp focus. I've put the detail where it belongs: on the figure and in the trees at the right. Everything else is very simply stated.

## Autumn Colors

It's a well known fact that autumn in New England is something to see. The month of October clothes our hills in kaleidoscopic color. The reds and golden yellows of the maples, the deeper reds of the oaks, and the burnished copper tones of the beeches and hickories set up a blaze of color that, in a good year, can be startlingly beautiful. This brilliant foliage becomes even more spectacular when contrasted with the dark greens of the pines, hemlocks, and other conifers.

This annual display brings forth a rash of garish paintings by amateur artists (and some professionals) who've never learned one basic lesson: when all the colors are brilliant, there's no brilliance. What may be breathtaking in nature can be plain gaudy in a picture. Don't ask me why, but it's true.

Oddly enough, I think autumn foliage looks best on gray days, or even in the rain. My favorite time is early November, when some of the leaves have fallen. Things have toned down a bit and there are some bare branches and twigs to add variety to the scene. I think of autumn as a beautiful but melancholy season.

The wild grasses, weeds, and roadside flowers are as much part of the autumn scene as the trees. I once painted a closeup of some weeds and called the picture *Columbus Day* because that was the day on which it was painted.

Here are the colors I use when I'm painting in the country during October and November . . .

I use gamboge and cadmium yellow for the more brilliant yellows, yellow ochre and raw sienna for the tawny yellows. Cadmium scarlet and alizarin crimson are for the reds. Burnt sienna and burnt umber are my browns.

These are all warm colors, so with them I take two cool colors: thalo blue and Payne's gray for mixing grays and the cool shadow tones.

I sometimes add a tube of Winsor & Newton light red to my color box. It's a useful color, something like Venetian red.

## Winter Colors

Thirty years ago, there were still a few of the old group of "snow painters" around. There are not many now. True, some artists turn out a snow picture now and then; but as a school, the snow painters have almost disappeared. The old timers went out into the snow to paint their pictures. I suspect that we're not as hardy—or just too lazy.

Yet winter has so much to offer. There's a feeling of quiet dignity about a winter landscape. Snow subjects give the watercolor painter a great opportunity for designing the picture space—nice areas of white or almost white paper, contrasting with dark tree forms. Then, too, there are the ochre colored grasses and gray, twiggy bushes that peep through the snow in our foregrounds, looking for all the world like a Japanese print.

I once saw a beautiful snow painting in which more than half the picture's surface was pure, uncovered white paper. Let me describe it in a little more detail. High up in the picture, there was a large hillside covered with snow; a scattering of partly covered rocks; a band of dark green fir trees on the brow of the hill, seen against a winter sky. There were just a few gray splashes in the foreground, but no paint on the paper until the trees were reached well above the center of the picture space.

The painter had designed his picture with care. The big empty white space, supporting the smaller dark area, was just the right size to suggest a snow covered hillside. If he'd featured the trees, he might have had a good tree picture, but one that wasn't half as effective as a snow scene.

Take advantage of the paper's whiteness. Think in terms of light and dark pattern. Don't let the light and dark be equal in size or importance. Do paint gray days. I'm very tired of those pretty snow scenes with the blue and purple cast shadows. They've sure ruined acres of good watercolor paper.

A good designer makes a thing of beauty of a snowscape. A weak designer merely produces a Christmas card picture.

In winter, we can see the anatomy of the trees. This is a good time to sketch. Now it's possible to see how the parts connect: trunk to branch, branch to smaller branch, and finally the twigs at the very end. The bare trees of winter make beautiful subjects to draw. I urge you to get into the habit.

What about color? Well, this is the season of grays: warm grays, cool grays, and all kinds of in-between grays; the silver grays of the beeches; the almost white gray of the birch; the dark gray of the oaks; and the green gray of the moss on the north side of many trees. Then, for contrast, there are the warm colors of last year's fallen leaves that carpet the ground. In Chapter 10, I deal at length with the floor of the forest as subject matter.

Most of my grays are obtained with burnt umber mixed either with Payne's gray or thalo blue. However, it pays to experiment with various combinations of warm and cool colors.

When mixed together, most warm and cool colors make gray tones. Other mixtures I've used are thalo blue with Winsor & Newton light red, and Payne's gray with burnt sienna. Remember, you can always gray a color by adding its complementary to it: blue to orange; red to green; and yellow to violet. For warm grays, add more of the warm color. To mix cooler grays, use more of the cool color. In other words, use more red or brown for warm grays, more blue for cool grays.

Mixing right on the paper while painting is a good method for painting tree trunks. I'll tell you how it works, but don't let it become a formula; if you do, all your trees will look alike and that would be deadly. Take a fairly large round brush—say a no. 8—and mix a puddle of burnt sienna. Avoid making it too dark. The value should be a little lighter than you want the

trunk to be when finished. Load the brush and paint the tree trunk rapidly from top to bottom. Now paint a cool tone into the warm tone of burnt sienna, wet in wet, and allow them to blend. I use Payne's gray for the cool color. To create a successful warm and cool blend, the washes must be put together while quite wet. This means that fast work is absolutely necessary. The Payne's gray, by the way, should be about the same value as the burnt sienna.

My palette for winter watercolor work is as follows: burnt umber, burnt sienna, yellow ochre, raw sienna, light red, thalo blue, and Payne's gray.

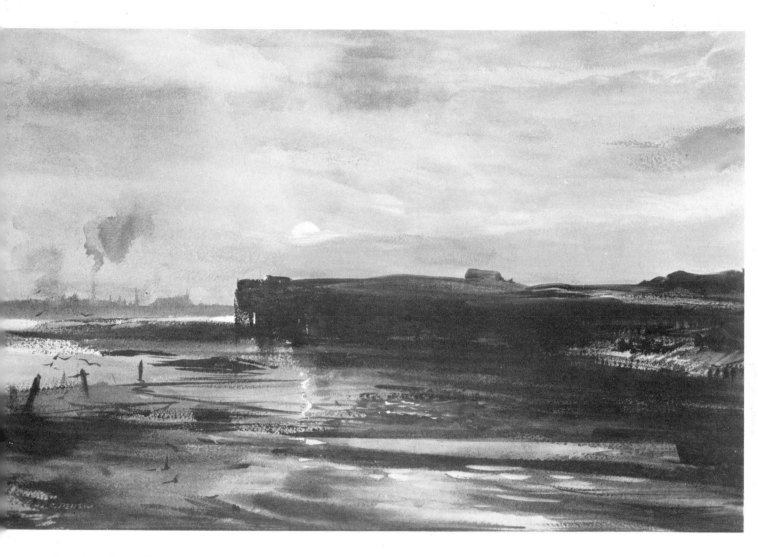

**Sunrise, Cape Spencer,** watercolor on paper, 15″ x 20″.

*The purist who holds to the belief that watercolor should be used in transparent washes wouldn't admire the technique used here. I like to experiment. I'd be bored stiff painting in exactly the same way, day after day, year after year. Let me explain the procedure used to paint this picture. First of all, it's a memory painting, done in the studio after a summer visit to Canada. It's not really a portrait of a place, but rather an impression of the Bay of Fundy's tidal flats, with the city of St. John in the distance. The color, ordinary watercolor, was painted into a fairly thick, wet coat of gouache white, which had been tinted with some yellow ochre. It was rapidly painted in order to take advantage of blending the color into the wet undercoat. For good darks, plenty of paint was picked up on the brush. Only enough water was used to make it flow. Some drybrush strokes were added as the paper dried. The distant city was transparent wash over dry underpainting.*

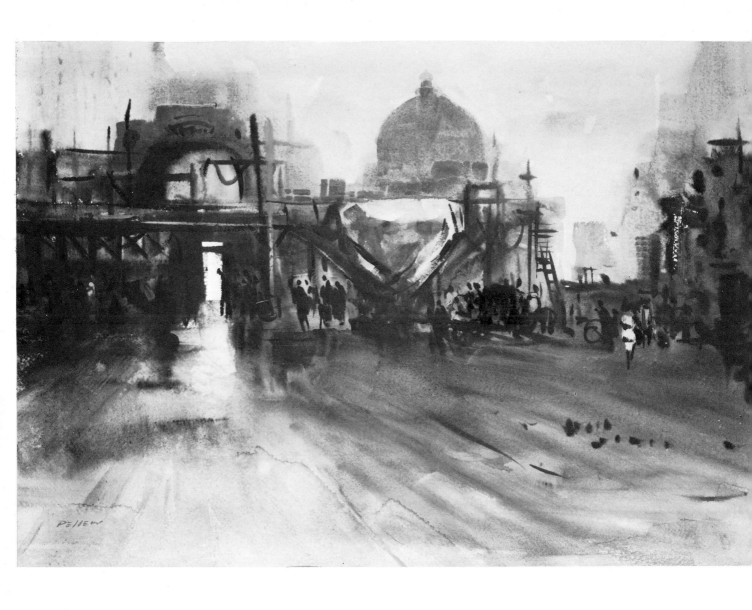

**City Theme,** watercolor on paper, 21″ x 27″. Collection, Jo Quackenbush.

*I wish I'd retained the very rough pencil sketch that provided the inspiration for this painting. There isn't much similarity between it and the finished work. Walking crosstown from Times Square, New York, I came upon a demolition gang tearing down an old theater. Being an old sidewalk watcher of such events, I couldn't pass it by, and I'm glad I didn't. The building that goes from the left side to just past center was all I had in my sketch. The rest was improvised in the studio as I painted. I invented the distant dome as I did*

*the bright light through the open door. The dome gives it a European look. In fact, the subject has been mistaken for war-damaged London because (to some) the dome suggests St. Paul's Cathedral. Of course, the big empty foreground didn't exist, except in my imagination. Note how very simply the figures are suggested— they consist of mere blots, stabs, and wiggles. The painting was started wet-in-wet on soaked paper. The more definite washes and darkest darks were, of course, painted in last.*

# Street Scenes

The street scene has been a favorite subject with watercolor painters for a long time, starting with the English "topographical school" who roamed the Continent on foot or by stage coach in the eighteenth century. These artsits brought back watercolors of the picturesque towns of France, Germany, and Italy. Some very wealthy men of the period even took an artist along when they made the grand tour—just as today we carry a camera to record the places we visit. Although these noblemen may have been lovers of art, I suspect that the real reason was the same one that now sets thousands of shutters clicking each summer all over Europe—to impress the folks back home.

## Popularity of Street Scenes

Anyway, it's to the watercolorists of that time that we owe the birth of the street scene as a subject, a subject that has held our interest down to the present day. In fact, no large watercolor annual is complete without its quota of street scenes. In recent years, outstanding work has been exhibited by Tore Asplund, Charles Kinghan, Ogden Pleissner, and Jerri Ricci, to name only a few. The first pictures I had accepted by the National Academy and the American Watercolor Society juries were street scenes of New York City.

I think this subject never seems to go out of fashion because it has human interest, without being a story-telling picture. The street scene is a slice of life, but not an illustration. It depicts something that the average viewer is familiar with, can enter into and enjoy. To the artist, it presents an opportunity to combine architecture, groups of figures, and the traffic patterns of today.

From the day when Bonington painted *A Street in Verona, with the Palace of Prince Maffei* to the day when I painted *The New York Public Library from 41st Street,* watercolor painters have been busy turning out what has become a traditional subject. I'm sure it's here to stay.

## Working from Sketches

During the many years I lived in New York City, I must have sketched and painted a couple of hundred street scenes. Some typical examples are illus-

trated in this book. The watercolors were painted from pencil sketches made on the spot. These sketches were done in small sketchbooks—small because I hate to appear conspicuous in public places. Some of these sketches are reproduced actual size in these pages. The beauty of working from these brief notations is that only the first vivid impression is retained. So much unimportant detail is forgotten—so much clutter that would only do your picture harm if you remembered it!

What you've just read contains the essential advice that the beginner needs to know about how to go about the business of producing street scenes. However, as we're on one of my favorite subjects, I'll elaborate.

If you've decided to tackle this fascinating subject, don't start by working from a photograph. That can come later, but not now. Get out on the street with sketchbook and pencil and draw the place—not from a window or a roof but right down on the street with your feet planted firmly on the sidewalk as passers-by jog your elbow and the cop across the road gives you a fishy eye. If you're too timid to face up to this, you'd better stick with landscapes and seascapes; street scenes aren't for you. Some artists have worked from a parked car with fairly good results. This is no permanent solution, however; although it may work for one or two pictures, you can't go on doing it. All your street scenes will look alike if you do.

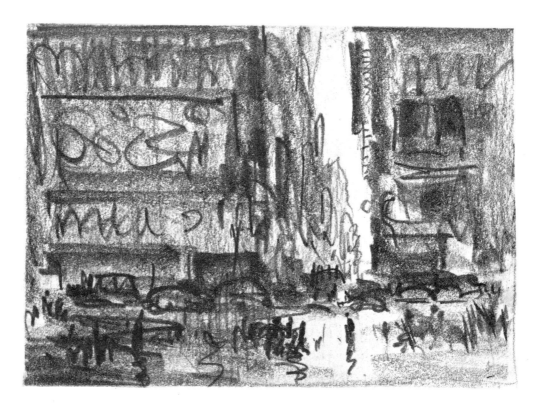

*This small pencil sketch was made in the Times Square area of New York City.*

**Street Scene,** watercolor on paper, 20″ x 27″.

*Looking down Fifth Avenue from 64th Street, this is one of the best of my many New York street scenes. These rainy day subjects were quite popular a few years ago. The half dozen good painters who did them have been imitated so much since that the subject has become almost a cornball. This one was painted (as most of my street scenes were) from a sketchbook drawing. The sketch wasn't made on a rainy day. My visual memory of how things look in the rain supplied the weather for the painting. A painter learns to observe and store up impressions of the visual world. The technique used in this painting is best described as semitransparent. Over a pencil indication of the main masses, I painted a thin coat of gouache white; while this was still quite wet, I painted the sky into it. The darker tones were added as the paper dried. Some of the undercoating of white is picked up as the paint is applied, imparting a misty quality to the scene. Opaque lights on costumes and foreground road were final touches.*

*From this sketch in pencil and Pentel pen, I painted Street Scene.*

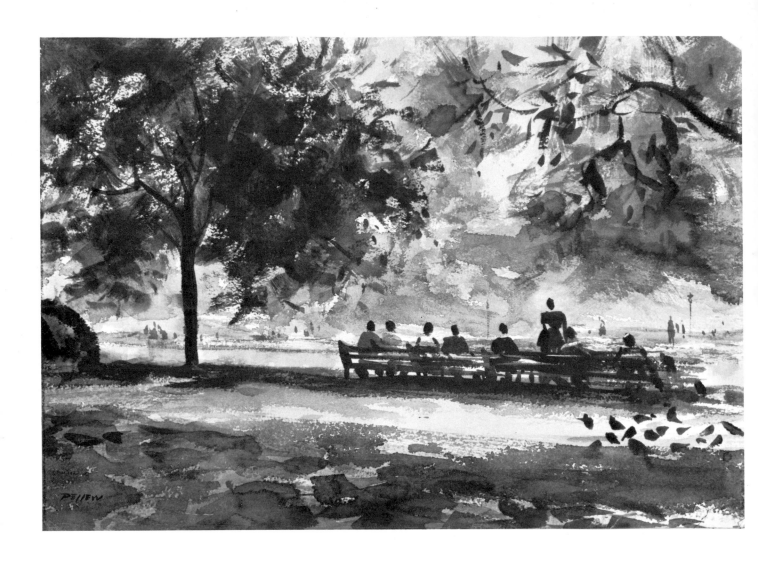

## Central Park, Summer,

watercolor on paper, 14″ x 21″.

*Sketching in the park was always fun when I worked in New York. I often went there during the noon hour, when office workers were out to lunch. Many of them would sit on the grass or on the park benches just to get away from the roar of the city for a short time. I filled many sketchbooks with quick sketches of them enjoying their lunch hour. The drawing from which I painted the above is reproduced. Notice that although I've held the big main pattern, some changes have been made. The figure leaning against the tree in the sketch doesn't appear in the painting. I think the composition has greater depth without it. The woman and child, suggested in the right foreground of the sketch, are also omitted in the painting because I wanted the people on the bench to be the single dominant point of interest. I kept the dark spots representing pigeons, because I feel they bridge the gap between the dark foreground shadow and the bench.*

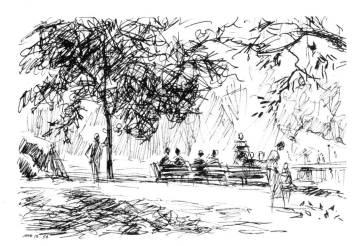

*This is a page from my Central Park sketchbook, in pen and ink. The picture painted from it is Central Park, Summer.*

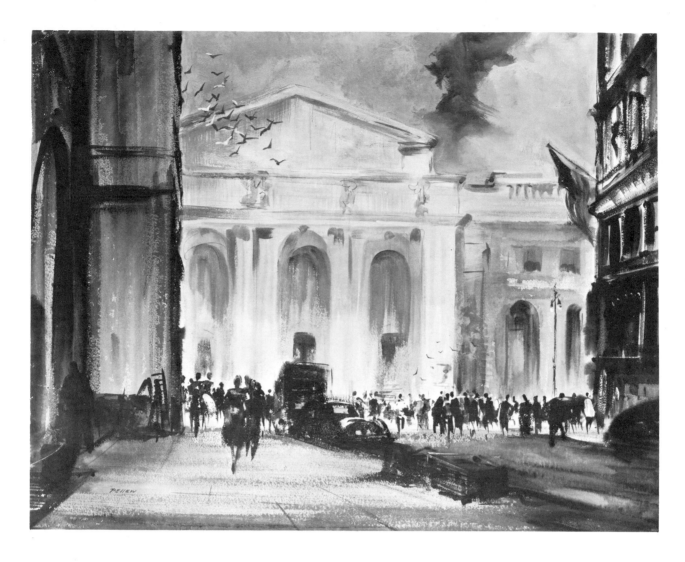

## The New York Public Library,
watercolor on paper, 20″ x 28″.

*The library has been a favorite subject with artists for a long time. In fact, an exhibition of the library in art was held there a few years ago. During the years I prowled the city in search of material, I passed it up because I thought there had already been too many pictures made of those smug-looking stone lions flanking the steps out front. I just couldn't see how the face of the building could be done without showing them. Then one day I happened to come through 41st Street just as the sun hit the façade, leaving the pedestrians in silhouette and most of 41st Street in shadow. My problem was solved—no lions. I made the rough pencil sketch reproduced here and went back another day to check on some details. The picture was painted in the studio. Note the absence of sharp edges and the overlapping figure, simply suggested. The flight of pigeons at the left and the flag at the right are used to break the strong horizontal lines of the library building. This is a boxlike composition, somewhat like a stage set. It doesn't bother me, as that's what a good street scene should be.*

*This pencil drawing was made for* The New York Public Library.

87

## Details and Color Notes

When you've drawn the street—or the part of it you want to paint—then make separate sketches of details you may need in your painting. I've often found it advantageous to make a fairly detailed drawing of a window, a cornice, or a lamppost.

I think all street scenes should be composed from sidewalk level. We're accustomed to viewing the world from there. You couldn't paint one from an airplane, anyway. So I repeat, keep your feet on the ground.

As you draw, try to soak in the color of the scene; I don't mean the colors of individual parts, but the over-all color.

A great deal will depend on the weather, of course. Early morning, with smog in the air, might produce pearl gray tones. Late afternoon, with a low sun, could cast deep violet shadows over most of a city street.

If there chances to be a good color note present—one that you think will help your painting—make a note of it. These notes on or alongside your sketch will be of value back in the studio.

## Designing the Abstract Pattern

Before starting a watercolor street scene in the studio, I sometimes make a second drawing from the one done on the street. This one I make larger: about one eighth sheet (7½" x 11"). In it I give the design of the picture space more consideration and try to work out a good abstract pattern. No matter how realistic the picture, it must be based on a good abstract pattern.

In the average street scene with buildings that are three or more stories high, chances are that one side of the street, or part of one side, will be in shadow. This, of course, is a great help toward designing light and dark patterns. Remember that nature seldom presents us with a ready-made composition, so never hesitate to make changes from nature if the composition of your picture will benefit. The big cast shadow on road and buildings can always be manipulated to improve the picture's design.

It is the cast shadows, in contrast with the sunlit areas of a street scene, that form the basis of the design or abstract pattern. There are other elements to be considered, such as dark windows or doorways; but the two big light and dark shapes are the most important.

What about a gray day, when there are no cast shadows, or a day when all the interest is on the sunny side of the street? Then you have to design your picture space carefully, using *shapes* and *colors* to create the abstract pattern. I've explained the meaning of this term in Chapter 5.

## Using Photographs

I won't deny that the camera can be a useful tool—if used intelligently. Many painters make use of photography, though few admit it. In my book,

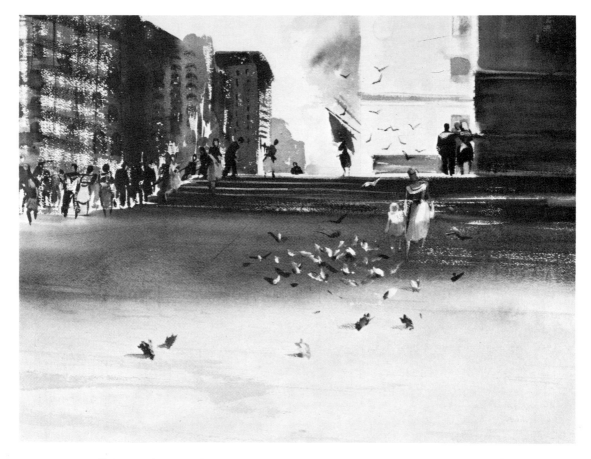

Painting from a photograph: Step 1. *This is the photograph that provided the data as well as the inspiration for my watercolor, St. Patrick's Pigeons. Notice how different this photograph is from the finished picture.*

Painting from a photograph: Step 2. *With the photograph before me, I select material from it with which to design the picture space. My thoughts are concerned mainly with creating a big, simple abstract pattern. The drawing is my final sketch for composition.*

St. Patrick's Pigeons, *final stage, collection of Howard Paper Mills, Inc. This is certainly not a photographic rendering of the steps of St. Patrick's Cathedral on 5th Avenue in New York City. After putting the photograph aside, I worked from my compositional sketch and from my memory. I prefer to call it an* impression *rather than a portrait of a place. The photograph merely provided a starting point. Note the very simple treatment of the figures. Also notice the variety of brushwork: drybrush on the buildings at the left, contrasting with the bold, simple washes on the right.*

*Acrylic Landscape Painting,* I listed some painters of the past who made good use of photographs: Degas, Vuillard, Gauguin, and Sickert are just a few. When you're working from a photograph, never let it dominate your thinking. There's no point in doing what the camera can do as well or better. A skillful copy of a photograph proves only that the painter is a skillful copyist, nothing more.

When planning a street scene, I take photographs if the locale is so busy with traffic that there's danger of being run over, or if the weather is too cold or too wet for me to stand and sketch. The camera is also useful as a recorder of detail; remember that window, door, and lamppost I mentioned a moment ago.

When taking photographs in the street, remember that unless you have special equipment, your camera will take in a lot more than you actually need. Get as close as possible to the part of the street that interests you. Take two or three shots of the same scene from slightly different angles. Before you press the shutter release, try to remember my advice on the importance of good composition in Chapter 5.

I suggest that you take black and white photographs, not color. Color film just isn't as true to the color of nature as the manufacturers would have us believe. The blues always seem to be too blue and too dark in value. Even in black and white photographs, the shadows photograph darker than they really are. Outdoors, there's actually a lot of light reflected into the shadows, making them luminous and transparent; but unless you're a professional photographer, with all kinds of expensive equipment, you'll get black or dark blue shadows which aren't in the correct tonal relationship to the rest of the picture.

So beware, don't use the photograph as a crutch. Use it as reference material. A good system is to make a drawing from your photograph—the kind of drawing you'd make if you were able to sketch on the spot. When you've finished the drawing, put the photograph away and paint your watercolor from the drawing. That's the way to avoid getting trapped by those photographic tonal values.

Above all, don't use the camera unless there's no other way out. There are too many painters hooked on photographs today, and their paintings suffer for it. Your painting should be as personal as your handwriting. A painting is still a handmade thing in a world of mechanical reproductions; it should *look* handmade—by a skillful hand, of course.

## Figures in Street Scenes

A street scene without figures is incongruous. A street needs people.

Putting figures into a street scene seems to be a stumbling block for many amateurs. The reason for this is lack of practice in drawing the human form. The street itself is often quite well done, but the figures are stiff and awk-

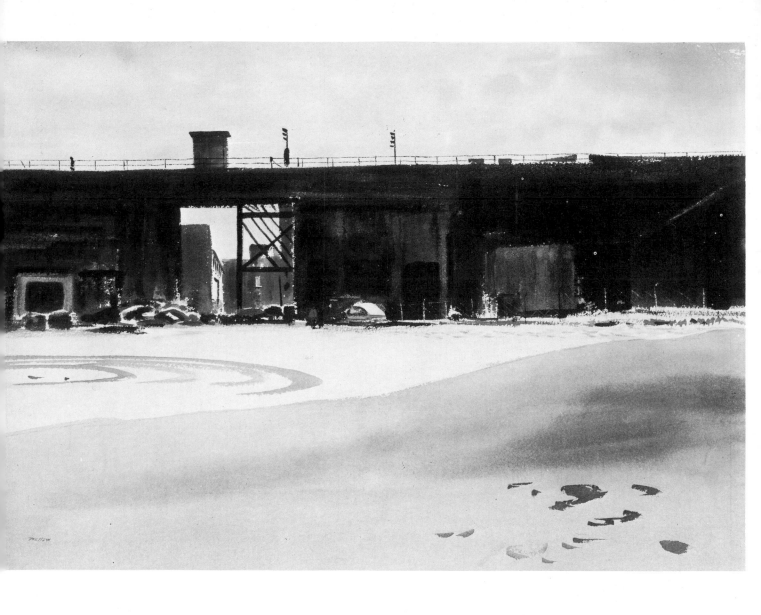

**Long Island City,** watercolor on paper, 21″ x 28″.

*I like the bigness, the stark simplicity of this picture: just a dark horizontal band dividing the space in exactly the right place. The light open area to the left of center adds depth and keeps the composition from being flat and monotonous in design. A similar device was used in City Theme. However, in this subject I didn't have to invent the composition. I passed this spot twice a day for years on my way to and from my home in Astoria, Long Island, to my job in New York City. I looked down on this empty lot from the elevated railroad— that's it at the top of the picture. It wasn't until I went for a long walk, one snowy Sunday, and saw it from ground level that I saw it as picture material. The dark areas in shadow are quite cool in color; a good deal of Payne's gray was used there. The buildings seen through the opening are in sunlight and they're painted in warm reds and orange. The light triangle of snow through the picture's center is mostly untouched white paper.*

*These figures were drawn from life with a ballpoint pen.*

*These figures were sketched with a No. 5 round watercolor brush and burnt umber.*

ward. The artist tightens up and the figures seem almost to be painted by another hand. Can this be overcome? Yes, it can, and I'll give you some good advice on how to do it.

First, always carry a small sketchbook and sketch figures from life whenever and wherever the opportunity presents itself. There are many places where you can sketch without attracting too much attention. Some of my happy hunting grounds have been parks, restaurants, trains, buses, and museums. These small figure drawings should not be concerned with details, but they must be concerned with proportion and gesture.

The gesture (or action) is very important because people on the street are mostly people on the move. These sketches must be done rapidly, which is a good reason for keeping them small. One reason—perhaps the chief one—for the beginner's failure is the fact that he becomes too concerned with what I call the three F's: features, fingers, and feet. Who needs them in a street scene? When you actually see people moving along the sidewalk of a city street, you aren't conscious of these small parts of the human body. The eye doesn't have time to take them in. You see only the big forms and the action.

See my illustrations of the kind of sketches you should learn to gather in your sketchbook. Note no hands, feet, or features; but the action, the gesture, is there. You won't need to know anatomy, but the parts should relate correctly. It takes practice. It takes time. It's worth it.

People on the street will often overlap, forming clusters. Don't make a separate project of each figure. When you put them into your picture, be sure they're in the correct scale—to each other and to the buildings. I've seen painted figures put beside a door, but so tall that they couldn't enter it without going down on all fours.

## Simplification

When we view an actual street scene, or look at a photograph of one, we see a million details—more so in the photograph than in nature. We take in the whole photograph at a glance. In the actual street, we see only the details of the part our eyes are focused on. That's why, when we paint a street scene, everything should *not* be painted with equal emphasis. Leave some parts more or less unfinished and work up the area you want to be your point of interest. An old instructor of mine was fond of saying, "Don't count windows."

Simplification in watercolor is more difficult to accomplish than overstatement. But a street scene can get out of hand and become an architectural rendering, instead of a painting, unless a determined effort is made to simplify. Working from photographs can be dangerous for the beginner. *All* the finicky details are there under your nose while you paint. Far better to work from a drawing and notes made on the spot. You also get a more personal statement that way—and that's the whole point.

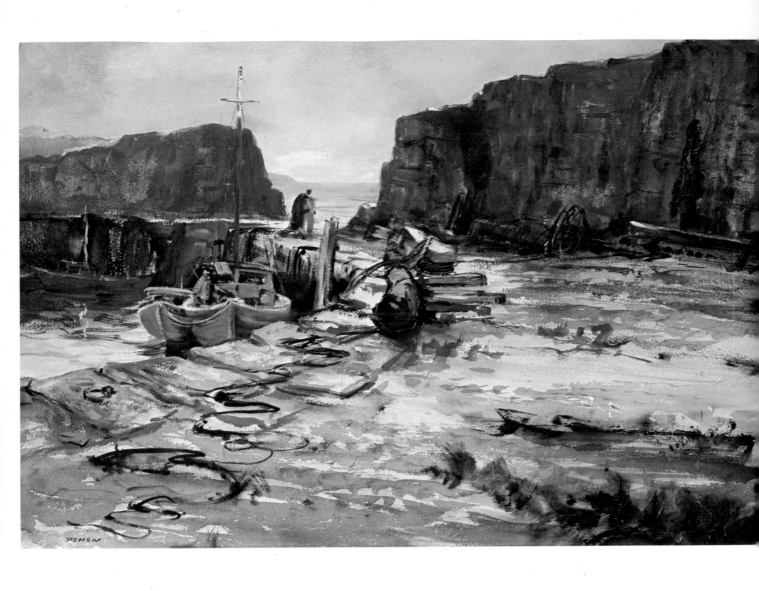

**Lanesville Cove,** watercolor on paper, 20″ x 28″.

*Fishing boats tied up to a wharf: I wonder how many summer vacation painters are attracted to this subject every year. I've seen hundreds of them. They aren't all bad. Some very good technicians do them again and again. But it always seems a pity to me that they appear content to paint the obvious. The boats and those never-to-be-neglected reflections are always dominant. Why not a little more care in selecting the point of view? This picture is a boat and harbor painting, but with a difference. I featured the wharf. Well, why not? It's interesting and has a lot of character. Of course, not all harbors are as picturesque as this one. However, a lot of those obvious boat pictures are painted in this very harbor every year. My advice is to take some time to walk around, viewing the subject from all angles. Decide what part you'll feature and don't paint everything with equal emphasis. You'll make a more personal statement if you follow this advice.*

# Marine Subjects

I've painted very few typical marines. By *typical*, I mean the breaking wave with rocks to left or right. The best seascapes of this sort are painted by specialists and, as a rule, are painted in oil. I don't see it as a good watercolor subject. I once hung one on my living room wall. Waiting for that oncoming wave to break almost drove me out of my mind. The picture had to come down, even though I admired the work of the man who painted it. I tell myself that Winslow Homer has said all that there is to say about pounding surf—and I let it go at that.

This doesn't mean that I have no interest in marine subjects. I love the sea and shore and never feel truly happy away from it. I grew up in a seaport town in England and I've lived most of my life on the eastern shore of the United States. A few years ago, I taught for a while in the midwest. I'd wake up at night and think about the ocean and how far away I was from it. It darn near gave me claustrophobia. I may not visit the beach for weeks at a time, but it's comforting to know that it's there.

## Don't Paint Stereotyped Subjects

You don't have to be a surf painter. In fact, unless you live on the coast and you've given a lot of time to the study of wave action, you'd better leave that branch of marine painting to the specialists. There's a wealth of other material along the shore. Boats, harbors, and beaches are my marines.

At times, I paint a cliff or some rocks; but in these pictures, the emphasis is never on the ocean. This kind of material has infinite variety; it's never monotonous, which is more than can be said of that typical marine of waves and rocks. My kind of coastal subjects are also great watercolor material.

## Boats and Harbors

The subject that too often attracts the summer vacation painter—on his annual visit to the coast—seems to be fishing boats tied up to the wharf: a green boat with a red strip at the waterline, blue water, and those wiggly

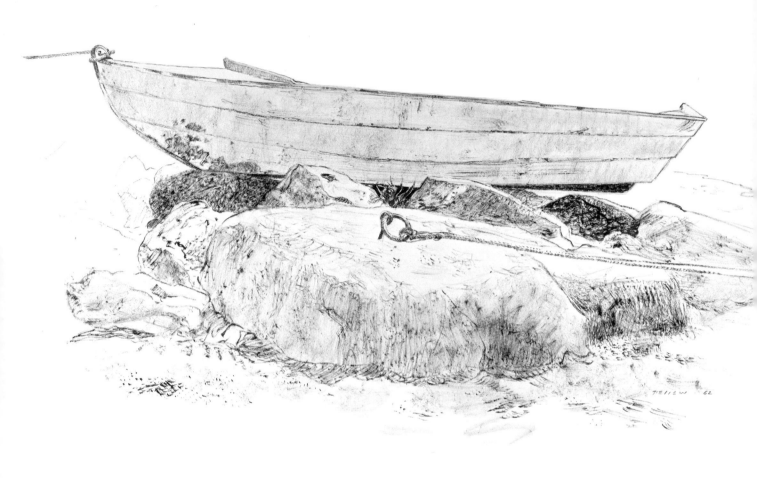

Drybrush drawing. *Sometimes, as a change from rapidly executed watercolors, I sit down outdoors and do a careful drybrush drawing. I sat on a hard rock so long to do this one that I could just barely get up when the drawing was done. I used waterproof black drawing ink, which I diluted with water to make it gray. The work was done with an old, worn out, round sable watercolor brush, and a small, pointed one for fine lines. I first sketched the subject with a 2H pencil. The paper is two-ply bristol board.*

reflections of boat and masts reaching down to the foreground. They're turned out by the hundreds along the New England coast every summer. In fact, they're rapidly becoming as monotonous as the breaking wave.

Don't misunderstand me. Fishing boats *are* good material. It's how you approach the material that counts.

Look at my picture, *Dragger Ashore.* Here's a typical Gloucester fishing boat—but this is *not* the typical Gloucester picture. Let me tell you how it came about.

One September afternoon, I walked down Rocky Neck, passed Gordon Grant's old studio, and went on to the shipyard at the end of the road. There was the big boat up for repairs. The scene, except for the boat, was not as you see it in my painting. The picture gives you an impression of the boat pulled up on a rather open beach; actually, it wasn't like that at all. There were buildings shutting out the sky behind the boat, a couple of small boats and a truck in front of it. I sat down on an upturned dory and made a fairly careful drawing of the big boat. From this, I did the picture in the studio.

I *invented* everything but the boat. For that, I had my drawing. I think I can safely say that this is not a typical New England harbor picture. My procedure for painting it is described in the caption accompanying the reproduction.

Now let's look at one that definitely *is* a harbor with fishing boats. The color plate titled *Lanesville Cove* was painted at Cape Ann, a popular place with summer painters. Notice that by featuring the huge stone jetty and making little of the boats, I obtained a *different* harbor scene.

I've seen a great many paintings of this spot, some of them good. However, all have had one thing in common. They've been painted with the boat or boats used as the dominant note or point of interest, the wiggly reflections always being treated with loving care. In other words, the artist accepted things *as is,* with no attempt to do anything other than the same old hackneyed fishing-boat-at-the-wharf kind of thing. It's good subject matter. But why not try to think your way out of the commonplace?

There are books by marine painters, describing boats, their construction and equipment, in great detail. It will do the beginner no harm to spend some of the winter months soaking up this information. However, you don't have to be an architect to paint a street scene; nor do you need the knowledge of a ship's carpenter to draw a boat. What you need is common sense and a lot of practice. My advice is that you carry a sketchbook and make drawings of boats of all kinds. Compare the parts as you draw and remember that good drawing is based on good observation. Look carefully at what you're drawing and *think.*

## Beaches

I like to walk along the beach at off season, when no one's there but the gulls. It's not that I dislike people. I like a pretty girl in a bikini as well as the

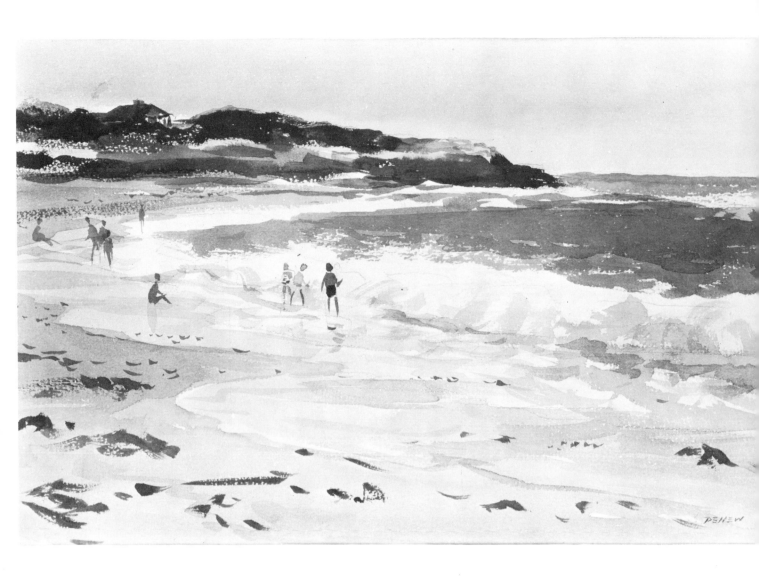

**Small Fry,** watercolor on paper, 10″ x 15″.

*This is a happy little picture. It was painted in bright, clean color with bold, untroubled washes and crisp brushstrokes applied directly to dry white paper. I painted it one bright, sunny day at Cape Hedges beach on Cape Ann: blue sky, blue ocean, white surf, and warm gray sand reflecting violet tones in its wet areas. The bits of dark seaweed, scattered along the beach, are merely indicated with bold brushstrokes. As this was painted in late summer, the vegetation on the head-* *land was quite warm and rich in color; I used a mixture of raw sienna, thalo blue, and burnt sienna. This last added warmth to the mixture. The lightest parts of the water are untouched white paper. Notice how simply the little figures are put in: just a few strokes to describe the action. Their bright colored clothing also adds a gay note. Small figures such as these, when properly proportioned and placed, serve to set the scale of the scene. Learning to do them is time well spent.*

next man. However, that's for watching, not for painting. I've painted beach pictures that contain figures, but the beach or sky has been the dominant theme, the figures incidental. The figures that fit best into beach paintings are the kind I suggested in Chapter 7 on street scenes—those quickly sketched, correctly proportioned figures without details.

Study the manner in which the children have been suggested in my beach picture, *Small Fry*. They're merely blots of color; but even without the title, you know that they're children. They also serve to set the scale of the place and to create a focal point.

When working on the beach, I think it's best to look *along* it—that is, up or down the length of the beach, not out toward the ocean. In that way, you avoid the repetition of parallel horizontal lines—beach, ocean, sky—that occur when you look straight out to sea. Looking along the beach, you get to see much more of the patterns created by beach debris, seaweed, etc. These dark notes can be used as elements of design in your composition. They can lend interest to the foreground (as they do in *Small Fry*, the picture mentioned above), or they may be designed to lead the eye into the middle distance, adding an illusion of depth to the painting.

There's always more debris on the beach in autumn than there is in summer. The storms that come along at that time of year pile up all manner of junk. After a hurricane, the beach is painter's heaven: pieces of smashed boats, rusty oil drums, rope, lobster traps, and all kinds of driftwood—sad and exciting at the same time. The beach is a happy hunting ground for the artist-beachcomber who's looking for interesting flotsam to be hauled into the studio for use as still life. The beach is not just sand and pebbles. It's a wonderland for those who have eyes to see.

## Painting Rocks

What about rocks? Winslow Homer once told a young painter, "Paint the figure; rocks are easy." Well, they're not *that* easy. The main thing to keep in mind, when painting a rock, is that it has a top and sides; it has form. Don't paint round, soft blobs that look as though you could push your finger through them.

Avoid painting a rocky coastal subject during the middle of the day; or at least wait until you've had enough experience to know how to handle it. At noon, the light comes straight down, giving the rocks top light only. The best time to paint anything outdoors—including rocks—is in the early morning. If you're too lazy to get up and out, set up ready to paint at seven o'clock, then wait until three in the afternoon. My best work in the field has always been done before ten in the morning! In the summer art colonies, I'm on my way home when the amateurs are gathering for breakfast.

Now, let's get back to the rocks. When the sun is fairly low—either morning or afternoon—the light is from the *side* and the form of the rock is modeled with definite light and shade. This tonal contrast makes it easy for

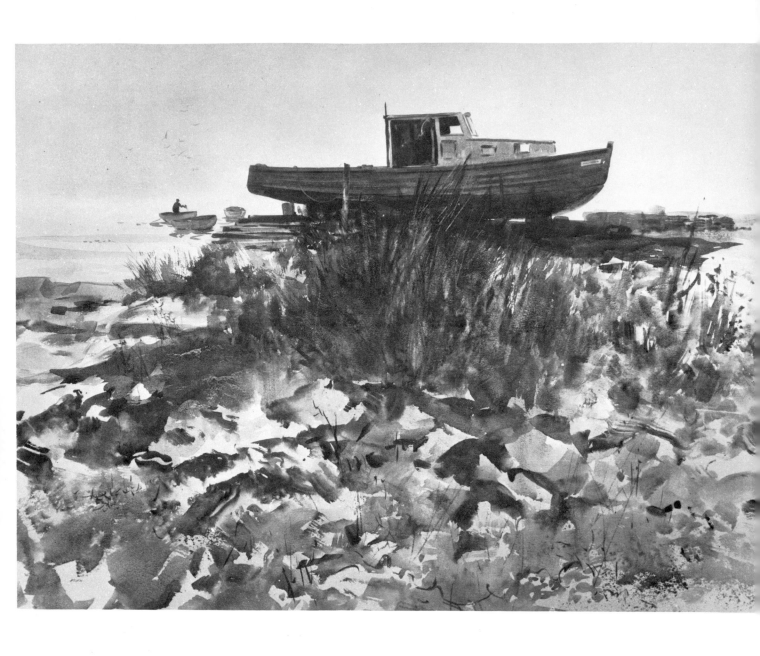

**High and Dry,** watercolor on illustration board, 30″ x 40″. Collection, Stevan Dohanos.

*This is larger than I usually paint in watercolor. However, I felt from the start that this just had to be a big picture. There was something about that old lobster boat, as I sat on the rocks looking up at it, that called for the larger size. This painting has something in common with my Bass Rocks picture, One on the Rocks. There's the same dark, massive silhouette, and the small figure for contrast. The studio painting was made from a sketch that I did at Lanesville Cove. For the student, this picture can serve as a lesson in what to leave out. First of all, there were actually two lobster boats, one* *behind the other. This was a confusing pattern, so I omitted one. Then, behind the boats, where you now see a misty sky, there was the big stone jetty with an opening leading to the sea. This same jetty can be seen from a different angle in Lanesville Cove. Well, that had to go out in order to create the big silhouette of the boat. The little man baling out the dingy was taken from another part of the harbor. I think this all goes a long way toward pointing up something I often tell students: "Never hesitate in taking liberties with nature if your composition can be improved."*

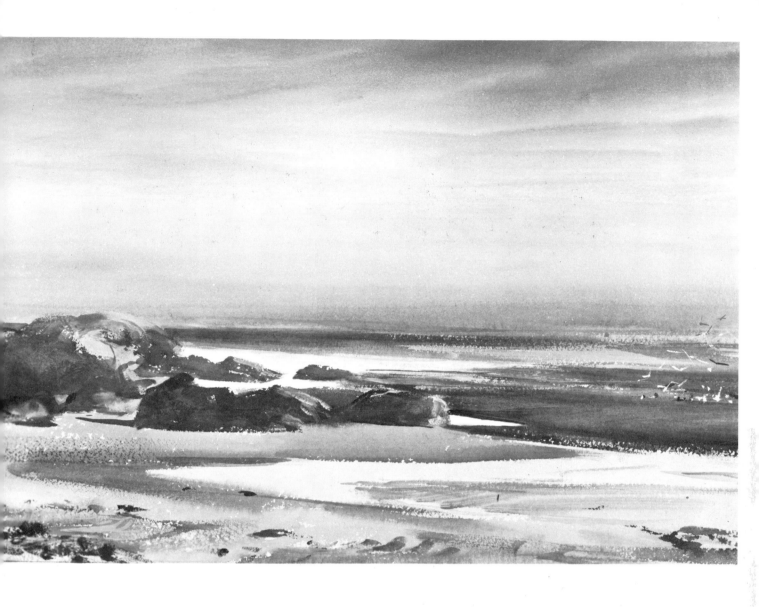

**A Cape Ann Beach,** watercolor on paper, 15″ x 20″.

*For several years, I had a "thing" about early morning painting outdoors. Painter friends would pick me up at our Rockport cottage before sunup and off we'd go to the beach or marshes in time to greet the dawn. A watercolor would be made before the beautiful early morning light changed. Then back through Gloucester and breakfast at the Hesperus Diner. This beach picture is typical of the work done during that period. It's a half sheet, painted on Wingaersheek beach at 7:30 A.M. in early September. The sky was blue-gray at the* *zenith, with a gradual change to a warm red-violet at the horizon. The sunlit parts of the rocks were yellow ochre warmed with a touch of burnt sienna. The shadowed areas were a cold purple, obtained with a mixture of thalo blue and alizarin crimson. Into this, some burnt sienna was painted where I wished to suggest reflected light. In the sand, I used yellow ochre and cadmium orange, with some violet shadows. The sunlit water was, quite simply, white paper, which was given a pale wash of cadmium orange.*

Rocks. *To paint a smooth, rounded rock (left), first paint the middle or halftone. Into this, while it's still wet, paint the darker shadow tone (2), allowing the two tones to blend softly. Let the top of the rock be the lightest value. To create rock texture with razor blade (right), paint the entire rock with its local color or middle tone (1). While this is damp, but not too wet, scrape the surface with the long edge of the razor blade; this should give you the texture (2). Paint in the dark shadow tones (3).*

us to impart a feeling of solidity to the rock when we paint it.

Don't forget the "character" of the rock. A smooth one can have a wet-in-wet treatment. Rocks with a rough textured surface can be suggested with drybrush; or the edge of a razor blade can be used.

When definite and visible brushstrokes are used, they can be allowed to follow the form. For instance, a low, flat rock can be described with horizontal strokes. Vertical strokes will impart a feeling of height to the face of a cliff. When painting a subject on a coast where many rocks occur, be careful not to make them all alike in shape and size. Although they may appear so at first glance, a second look will show you that no two rocks are exactly alike. Keep their shadowed parts simple in treatment. Put detail and texture in the lights.

## The Salt Marsh

Now for a few words on one of my favorite subjects: the salt marsh. Many of my readers have never seen one, I'm sure. It's simply a tract of low land along the shore, mostly flooded by the ocean at high tide. Streams flow into it from the surrounding country, cutting channels and forming ponds of brackish water where salt and fresh water meet and mingle. The parts above water are covered by a coarse grass, called salt hay. This is often two or three feet tall, green in summer, a lovely warm golden ochre in fall. Behind the marshes rise the dark pines.

The beautiful patterns formed by the salt hay and the water have great appeal for me. The two-color demonstration described in Chapter 3 is as good a procedure as any for painting a salt marsh. Of course, more than two colors may be used, but the emphasis should be on design. Pictures of marshes, or any flat country, are best composed with plenty of sky; so keep your horizon line below the center of the picture space.

## Avoid the Obvious

A final word of warning to those of you about to paint marine subjects. Do avoid the obvious. Remember that the picturesque fishing boat, tied up to the dock with wiggly reflections in the water, has been done to death. Skip it. There's a wealth of material around. Keep your eyes open as I did the morning I found *Gulls at Low Tide*. Try for a personal statement. It's worth the effort.

**Gulls at Low Tide,** watercolor on paper, 20″ x 28″.

*When I was a little guy, somewhere around twelve years old, I was wandering one day around the harbor of St. Ives. It was summer, school was out, and there were hundreds of gulls around and lots of those good, pungent, low tide smells to smell. Suddenly I was aware that there was a man standing on the mud before me, painting a picture. I'd never been that close to an artist before. Of course, I'd seen them. Many had settled in Cornwall and more came each summer. However, we boys kept our distance. Artists were "gentlemen" and from up country. This one was painting the mud and the gulls—not the pretty lighthouse or the view of the*

*church from across the harbor, just mud and gulls. I thought it was great. I've never forgotten the thrill of that day. If there was any one thing that made me want to paint, that was it. After I started in art school, I saw more of the painter's work and learned his name. Charles Simon is a well-known British painter of wild life and has done important work in that field. Elsie and I visited him a few years ago at his home in Penzance and I told him the story you've just read. The gulls in my painting aren't at St. Ives, but in Rockport, Massachusetts, which could be called the American St. Ives.*

**A Long Island Beach,** watercolor on paper, 19″ x 27″.

*I like the off season beach, when the sunbathers—those golden boys and girls—have departed and I'm left with the gulls and sandpipers to walk the hard packed sand near the water's edge. This watercolor was painted at Jones Beach, New York, late in September. It was painted rapidly. Due to the constantly changing cloud formations, all manner of dramatic lighting effects were taking place. It was necessary to make the brushes move as fast as possible. When you're faced with a problem of this kind, the painting procedure actually becomes a feat of memory. You're sure to end up in a dreadful mess if you try to follow each change as it occurs in the scene before you. What you have to do is to wait for an effect that pleases you. Study it while it lasts. Then, when it's over, go to work with that particular effect in mind and stay with it no matter what happens. Sounds difficult, doesn't it? Well, I've never said watercolor was easy or that it could be made easy. However, it's not as difficult as you might think if you're able to make up your mind to make a simple statement—sometimes the most difficult thing to do. Notice that the brushwork in the ocean and in the beach is calligraphy that describes ocean and beach, rather than depicting them photographically.*

**The Salvager,** watercolor on paper, 21″ x 27″. Collection, Edwin Larsen.

*Many of my best marine subjects have been painted from material gathered on Cape Ann. This is a good example. While I was staying at Rockport a few years ago, a painter friend came with the news that a fishing boat had gone on the rocks near Brace's Cove the night before. He said that she was already breaking up, but might be worth a look. Armed with sketchbooks, we started for the wreck—and I'm glad we did. From that expedition came two good pictures. One called The Wreck of the Sea Prince was awarded a Henry W. Ranger Purchase Award at the National Academy in New York and the one above was purchased by a Cali-*

*fornia collector. This is a fairly opaque watercolor. I first indicated the composition roughly in pencil. Then, using a large flat brush, I gave the entire surface a coat of gouache white warmed with a touch of yellow ochre. This was thin enough to allow my pencil lines to show through. Into this wet, creamy white, I painted my colors, starting with the sky. For the darkest darks, the paint was used almost as thick as it comes from the tube—just enough water to make it flow. Notice how the lines of the wreckage lead the eye to the figure, and how the short, upright post at the right keeps the eye from moving out of the composition.*

# Mountain Country

It isn't difficult to paint pictures of mountains—but it's darn difficult to paint good ones. By good ones, I mean pictures that have some art quality and aren't merely a recording of scenic beauty. A mountain isn't only beautiful, it's majestic. There it sits in all its splendor, sparkling in the morning sun, blue and deep purple at sunset. Even in midsummer, there are snow patches on its summit. Sure it's beautiful; but it's also made to order for corny calendar art. If, by chance, there happens to be a small lake at its base—and there often is—the total effect is just too much.

Painted scenes of this kind were greatly appreciated in the 1880's. Perhaps we'll get back to this sort of thing—but I hope not. Thomas Moran and Frederic Church were great painters of big mountain panoramas; however, they both did sketches on location that have greater appeal for us today than their larger, more finished compositions. Moran's small watercolors, painted in the Rocky Mountains, are little gems; Church's sketches of the ravines and ponds of Mount Katahdin in Maine are fresh, spontaneous impressions, with qualities that just don't come across in his big, overworked exhibition pieces.

The mountains are dangerous ground for the realistic painter. It's so easy to be carried away by what nature has spread before you with such a lavish hand. Once, while on a painting trip in the Rockies, I overheard a student ask, "Why did he come to Colorado if he doesn't like to paint mountains?" The dear lady was wrong, of course. I do like mountains, but I think that they must be approached with caution as a painting subject. You have to compose and select carefully. If you allow nature to dominate your thinking, you'll wind up with a picture postcard or something that could have been done just as well (or even better) with a camera and color film.

## Don't Take in Too Much

The common error—so easy in the mountains—is taking in too much. It's very difficult to teach the beginner to appreciate the beauty and strength of simplicity.

For instance, when painting a mountain stream, the inexperienced student will not only paint the stream, but the woods beyond the stream, the foothills

in the middle distance, the mountain range beyond that—and top it all off with elaborate sky and cloud effects. Actually, the subject is the mountain stream: sun dappled rocks, fallen timber bleached to shades of pearl gray by exposure to the elements, swirling water, and dancing reflections. This is certainly enough to tell the viewer who sees the finished work that the artist was in the mountains. More important, the artist has created a composition that has unity, a picture with *oneness*.

The point I'm trying to put over is this: don't paint the obvious.

When I paint a mountain, as I sometimes do, I try to simplify the detail as much as possible. If I can, I avoid painting everything with equal emphasis: I leave something for the viewer to exercise his imagination on.

## Panoramas and Closeups

It's been my experience that the best mountain compositions are either panoramas of mountains in the distance or closeups—like a bold study of a rocky ravine or a rushing stream.

Mountains at a distance are often lovely in color, lending themselves to big brushwork and simple treatment. The closeup is a subject for rugged forms and rich textural effects. In between views are half way measures; they're seldom successful because so much detail is taken in that the various elements compete for attention.

My advice to the young mountain painter is this: either paint from the valley or leave your car on the road and take to the trails on foot. I walked the trails of the New Hampshire mountains every summer for several years. I learned a lot about the subject and especially about the kind of equipment to be taken along . . .

## Equipment for Mountain Painting

Working at the base of the mountains, a short distance from the car, presents no problems as far as equipment is concerned. However, climbing a steep trail, or making your way through a ravine strewn with loose rock, is another matter. The gear you carry must be kept to the minimum. Forget the easel; it will be a nuisance. You won't need a folding stool either. There's always a rock or a big log to sit on.

I put everything I need in a small knapsack. This has a shoulder strap which leaves both hands free when needed. Now here's what goes into it.

(1) A piece of plywood just large enough to hold a quarter sheet of 300 lb. cold pressed watercolor paper (11″ x 15″).
(2) Three or four extra pieces of paper, the same size.
(3) A flat tobacco tin containing tubes of paint.
(4) Four brushes, rolled up in a rag. The brush sizes I usually carry are a ¾″ flat oxhair, and three round sables, numbers 8, 6, and 2.

**The Little River Range,** watercolor on paper, 22″ x 30″. Collection, Donald Holden.

*This picture has often been mistaken for a western scene. Actually it was painted in New Hampshire. The time is early evening, the color somber. It is a mood picture, an attempt to capture some of the poetry of the place and the time of day. It's a silent picture. There's no sign of life—not even a bird. The sky is a graded wash, cool gray at the zenith and gradually warming as it comes down to the horizon, where it's a dull, grayed red. The dark mountains were painted all at one go, with a well-loaded No. 10 round sable brush; the color*
*used was Payne's gray warmed with a little cadmium red medium. The flat foreground was painted in dull browns and greens. I think the colors used for this were burnt umber, burnt and raw sienna, and Payne's gray added to the mixture where green was required. There's drybrush in the middle distance as well as in the lower foreground. The light streak just to the right of center was scraped out with a razor blade. This is a quiet picture, but for all its low-keyed simplicity, it's a picture that's difficult to forget.*

**Mount Washington,** watercolor on paper, 10″ x 19″.

*A bold, simple statement in the traditional manner: transparent washes with the white paper gleaming through all but the few darkest darks; not a smidgen of opaque in it anywhere—a fact guaranteed to please my purist friends. There's some drybrush which was added to create textural interest. This can be seen in the land areas, but not in the sky, where I think drybrush is out of character. The picture was painted near Twin Mountain, New Hampshire. I spent many vaca-tions on a farm near this spot. This view across the meadows to distant Mount Washington always re-minded me of watercolors by some of the British Vic-torian artists. I guess that's what influenced me to use the traditional approach when I came to paint it. The long horizontal shape of the picture departs from my usual picture size. I think it's a good idea to get away from the standard 22″ x 30″ or 15″ x 22″ now and then. It keeps you from getting into a compositional rut.*

110

(5) A flat folding palette.

(6) An army canteen filled with water.

(7) A plastic water pot—the bottom half of a plastic detergent bottle, cut off with a razor blade.

(8) One HB pencil.

(9) A kneaded rubber eraser.

(10) Masking tape to hold the paper to the board—a piece at each corner of the sheet.

(11) A couple of razor blades; wrap them or carry them in a matchbox.

(12) The last thing—but very important—my lunch.

That's my kit for rough country. Small sheets of paper are necessary in order to fit the board into the bag. I sometimes carry one eighth sheets (7½″ x 11″) as well as the quarter sheet size (11″ x 15″). Some of the best landscape sketches I've ever seen were no larger. In recent years, huge, over-size papers have been shown in exhibitions. Although I've been guilty of painting some large ones, I feel that the real reason for these large pictures is to command attention on the exhibition wall. Winslow Homer and John Singer Sargent painted half sheets (15″ x 22″) in watercolor. The full 22″ x 30″ paper should be large enough for anyone.

## Composing Mountains

Let's get back to the mountains.

When you're ready to compose your mountain picture, make up your mind right at the start about how much sky you'll have in the composition. My advice is to have more sky than land or more land than sky. An example of the first—more sky—is *Mount Washington*. An example of the second—more land—is *The Little Cimarron*. When there's an equal division of the space, the same amount of land and sky, the composition is never as interesting.

Composing means designing the picture space. So think of design before you think of details. The experienced professional knows at once where he'll place his horizon line on the paper. The beginner had better give it a little thought.

Design is pattern, and balance is obtained by the manner in which you place your light and dark masses. Don't carry a still life approach to nature.

By pattern, I mean the abstract pattern of the main masses—their shapes and tonal values, minus all details. Even the most realistic picture should be based on a good abstract pattern.

When I warn against carrying a still life approach to nature I simply mean that the over-all design of the composition should be thought of before you think of the subject itself. It may be a tree or a barn, but that's not as important as how its shape or size will work within the four sides of your

**Burroughs' Barn,** opaque watercolor on paper, 20″ x 28″.

*I painted many pictures of this farm in Twin Mountain, New Hampshire. The Pellews spent vacations there for several years. Our cottage was at the foot of the mountain. It's hidden in the picture by the barn. What was a well-kept place in those days is now abandoned. After a farewell visit a couple of years ago, I painted the farmhouse as it now stands, surrounded by weeds and boarded up. That picture was reproduced in my book,* Acrylic Landscape Painting. *The painting above was done on the spot. Although I seldom do large pictures outdoors, this is a full sheet and, because of its size, I used an opaque technique. Gouache white was used with regular watercolors—plenty of paint and not too much water. Flat bristle oil painters' brushes were used throughout. The reason for using opaques and large, flat brushes was to cover the sheet as rapidly as possible, in order to capture the swiftly changing light of the breezy September morning. Working in this manner, I avoided the maddening wait for large, wet washes to dry. It was a sharp, clear day. Notice the contrasting light and dark tonal pattern. The bump on the skyline at the right is Nubble Mountain.*

**Naomi Painting,** watercolor on paper, 20″ x 28″. Collection, E. C. McCormick, Jr.

*I often make use of my friends as models. This one is Naomi Brotherton, an artist in Dallas, Texas. A few years ago, I conducted a workshop in Joplin, Missouri, and Naomi joined the group. As it was summer, we painted out every day. Each morning, I'd select a subject and do a demonstration painting in watercolor. Then the group would paint. Usually they'd paint the subject I'd used in my demonstration. However, the young lady above had a mind of her own—so here she is in splendid isolation, alone with nature. The white jacket against the blue-green shadows cast by the trees, and the black slacks contrasting with the white watercolor paper she was working on, were just too beautiful to miss. A quick pencil sketch of the figure was all I had time for. The rest was improvised when I painted the picture weeks later in my studio. After drawing the figure carefully, I painted the landscape around it, working from light to dark. The figure and the dark treetrunks were the last things painted. The cast shadows were painted rapidly with a fully loaded 1″ flat sable over the lighter underpainting, which had been allowed to dry. Notice how drybrush adds texture.*

paper. I use the term "still life approach," to denote an over-concern with detail and not enough concern with design.

If you want the mountain itself to be the focal point, try to design the space in a way that leads the eye to it. Avoid being too obvious about how you do it. Curved lines are better than long, straight ones that rush the eye to the point of interest.

I can't set up any rules for guiding the eye to the point of interest. Each landscape presents different problems. However, let the viewer have room to enter your composition with ease. Avoid a skimpy foreground and remember my advice about curved lines. Don't run the line where land and water meet —at the bank of a stream—right to the lower corners of your picture. This tends to run the eye out instead of into the composition.

Another way to call attention to your point of interest is to make it your darkest dark or lightest light. In *Naomi Painting* they're both together. The jacket is the picture's lightest value and the black slacks are the darkest. This also occurs in *Museum* where the black coat contrasts with the pure white of the shirt.

## Minimizing Detail

If you've decided on the mountain you want to focus on, then paint it as you see it when you look straight at it. Concentrating on this one area, you'll find that the foreground appears indefinite, so handle this foreground broadly and avoid the temptation to overload it with finicky details. In other words, don't paint everything with equal emphasis.

If you leave the highway and walk into the mountains, your subject matter will most likely be streams, waterfalls, rocky ravines, and forests. You seldom see the sky; or if you do, it's best to forget it and compose a fairly closeup view. Select something as your point of interest, but try not to get it in the center of the picture space; let your light and dark masses, or the linear pattern, lead the eye to it. Put a little more work into this focal point than into the rest of the sketch. Parts—perhaps the foreground—can be left unfinished. You'll have a much more interesting watercolor this way than you would if you'd painted it all in complete detail from corner to corner of the sheet.

On the other hand, if the foreground and middle distance are what attracted you in the first place, then concentrate on those parts and let the background mountains be treated simply. This isn't always easy to do—and for a very good reason . . .

At high altitudes, the air is thin. It's very clear and there's little separation of tonal values. The details on a mountainside ten miles away are as distinct as those of the foreground. I found that this presented quite a problem in the Rockies, for instance.

When I was painting on the Little Cimarron River, the distant mountain

was sparkling in the sun. Every distant rock, from the biggest boulder to the smallest pebble, was casting a shadow that I could see as clearly as I could see those right at my feet. How could I paint the scene and get some feeling of depth or recession into the picture? By taking some liberties with nature, of course.

By putting some clouds in what was actually a clear sky, I created an excuse to use cloud shadows on the landscape beneath. This gave me a chance to simplify the mountains, using a bold painting treatment. The river, running "summer shallow" through patches of uncovered rock and pebbles, was quite interesting in design and texture, so I kept the sparkle there and solved the problem of drawing attention to that area.

Even the realistic painter doesn't merely copy nature. It's the personal style of the artist that makes art interesting. That day on the Little Cimarron, I knew that a literal copy of the values as I saw them would result in a flat picture. I had to select what to emphasize and what to treat simply.

This kind of thinking goes on constantly in the mind of the landscape painter when he's face to face with nature. My advice to the beginner is: think more about what you can *leave out* than about what to put in. Chances are you'll put in too much anyway.

**The Jury,** watercolor on paper, 11″ x 15″.

*This is certainly a change of pace. Let me tell you how I came to paint it. I once taught an evening class for the Art Association of Jackson Heights, New York. There had been some of the usual complaints from students about not knowing what to paint. I maintained that there was always something to paint, no matter where one might be. The idea that you had to go somewhere to find picture material was just not true. I asked them to look around the room for a good subject. They couldn't find one. I then started to paint the coatrack. When I finished, they had to admit that I'd found a subject—one that was there all the time for anyone with eyes to see.*

 *Sometime later, I made a large painting from this small demonstration sketch, called it* The Jury *and exhibited it in New York. It was purchased by a lawyer who, no doubt, was intrigued by the title. Actually, when I called it* The Jury, *I was thinking of an art jury. He, of course, thought of a courtroom. You see how important titles are—even when they're misconstrued.*

# Interiors and Closeups

Now and then, as a change from landscape, I paint an interior. Many of these have been painted from material gathered in museums. The museum interior has great appeal for me. There's always an interesting variety of people wandering through the rooms, different types that strike intriguing attitudes as they stop to view the masterpieces displayed on the walls. Those great works, with their ornate carved and gilded frames, lend themselves so well to the design of my picture space. They present a great opportunity for a geometric abstract pattern within a realistic concept. The rectangles and horizontal lines of large and small pictures, contrasting with the vertical lines of the standing figures, almost design themselves.

## Working from Pencil Sketches

However, my first museum interior was something quite different. It was a painting of the main stairway of the Metropolitan Museum of Art in New York; the view is looking up the stairway from the floor of the main lobby. Except for some bright color in the paintings, shown in a well lighted gallery at the top of the steps, the picture is gray in tone. This watercolor was painted from a small pencil sketch made at the museum. Although the painting was made several years ago, people still take pleasure in telling me how they enjoyed it when they saw it at the American Watercolor Society exhibition.

All my interiors, except those painted from memory, have been done from pencil sketches. The one called *Viewing Constable,* now in the Butler Museum of American Art in Youngstown, Ohio, is actually a combination of two sketches. The gallery was sketched at the Victoria and Albert Museum during a visit to London. The figure is from one of my Metropolitan Museum sketchbooks. The large painting behind the man is my free interpretation of Constable's full size sketch for the painting known as *The Leaping Horse.* On the wall at the left are displayed a selection of that artist's beautiful small landscape sketches. (When on a visit to London, the Victoria and Albert is a must for students of landscape painting.)

*Appreciating Turner* was painted from memory the day after seeing the Turner exhibition at New York's Museum of Modern Art. The dark silhouettes of the figures against the lighted walls were what intrigued me here.

This picture and the Constable subject are both wet watercolors: both were painted on paper that had been previously soaked in water for about twenty minutes. I started by floating in the lighter tones, then added the more definite washes and final darks as the paper dried.

## Wet-in-Wet Interiors

Plenty of pigment must be picked up on the brush to obtain a good dark when you're painting wet-in-wet. If this isn't done, the value will be too light when the paper has dried. All my soaked paper, wet-in-wet watercolors are done in the studio. Outdoors, I prefer to work directly on the dry paper.

Whether you're working wet or dry, things happen that can surprise even a professional. The wet-in-wet approach is always an adventure. Accidents will happen. If they work for the good of the picture, I leave them. If they don't, I swear and start over on a new sheet of paper.

Wet-in-wet seems to work well for interiors. It keeps the horizontal and vertical lines—such as door frames and the area where the floor and walls meet—from becoming too edgy. It also lets a feeling of atmosphere into the room. Even though this atmosphere might not have existed in the actual room, the wet-in-wet method does make the picture more interesting as a work of art.

## Planning the Picture

If you decide to paint the kind of interior I've described, first study the place carefully. Soak it in visually. Get the feel of the place firmly established in your mind. After all, learning to paint is a matter of training the eye as well as the hand. When you get to work in your studio, you may be surprised at how much you remember. Of course you'll also forget a lot—which is good, because you tend to forget non-essentials.

The second step is to make a sketch in pencil or pen. This needn't be large. About 5″ x 7″ is a good size. Mine are often smaller. Don't take in too much of the room. You won't need the ceiling. If there's a doorway leading to another room, make use of it to give your composition depth. Check the perspective as you draw. Establish your eye level and keep the floor flat. Remember, you're going to place figures on it.

Let the room be a stage and the people your actors. This was the method of the Dutch "little masters" like Vermeer and DeHoogh, who were great painters of interiors. They thought of the picture space as a box—as did the English master, William Hogarth, when he painted his social dramas, *The Harlots' Progress* and *The Rake's Progress*.

**From the Top of the Tulip Tree,** watercolor on paper, 21″ x 28″.

In the woods behind the studio, there was once a tall tulip tree. Unfortunately, during an autumn storm, it was struck by lightning. On looking over the debris, I found the remains of the tulip shaped blossoms still clinging to some of the twigs. Growing as they do on the top branches, they're seldom seen. I'd never seen them before. The leaves surrounding them had turned a dark brown. Whether this was autumn coloring, or due to the heat of the lightning, I don't know; the latter, I suspect. The "flowers" were a nice warm golden ochre. I carried a bunch indoors and hung them on the studio wall. Against the white plaster, their dark colors were handsome indeed. My painting is a bold, freely handled impression, but I think I captured the character of the subject matter. First, I lightly indicated in pencil the position and overall shape of the leaves. Then, using a 1″ flat brush, I painted the wall, mingling warm and cool tones wet-into-wet as I worked. This was done directly on the dry paper. The colors used were very pale-washes of burnt sienna and Payne's gray. The leaves were painted with burnt umber, burnt sienna, yellow ochre, and raw sienna.

**Appreciating Turner,** watercolor on paper, 20″ x 20″. Collection, Mr. and Mrs. Coston C. Crouse.

*This was painted from memory the day after I saw the Turner exhibition at New York's Museum of Modern Art. I sat on a bench in the gallery for an hour and watched the people pass in front of these great works of art. The lights that illuminated the paintings made silhouettes of the figures. Wonderful contrasts of light and dark occurred. It almost seemed as if the brilliant color of the Turners caused the silhouetting and the cast shadows—an effect too good to be missed. I made*

*no preliminary sketches on the spot as I felt that the mood could be created best by working from memory. In the studio, I first soaked the 300 lb. paper in water for about twenty minutes. Then I started by floating in the lighter tones, concentrating on the wall and the floor. Nothing was drawn, except a light pencil line indicating the floor level and the position of the three Turners. These, along with their ornate gold frames and the figures, were painted directly as the paper dried.*

**Museum Number One,** watercolor on paper, 26″ x 28″. Collection, Roy Mason.

*The first of my museum interiors. It's easy to see from the length of the skirt worn by the young woman in the foreground that the picture isn't a recent one. I think this is a good example of how a complex subject can be simply treated. Look at those steps, for instance. The character is there, but not the detail. That's the secret of good watercolor—resisting the temptation to overdo. An architect would have used a T-square and a ruler on those steps. Except for the brilliantly lighted gallery at the top of the stairs, the color is a warm gray. The values are close in tone to place emphasis on the dark pattern made by the figures. Notice how they've been placed to lead the eye with ease up the steps and into the gallery. Their diminishing size gives the picture depth. The two seated at the right act as a balance. The only bright colors are in the paintings simply suggested on the walls of the gallery, and in the clothing of the small figures in that area. This picture is owned by the great American watercolorist, Roy Mason—and that's just about the finest compliment I was ever paid.*

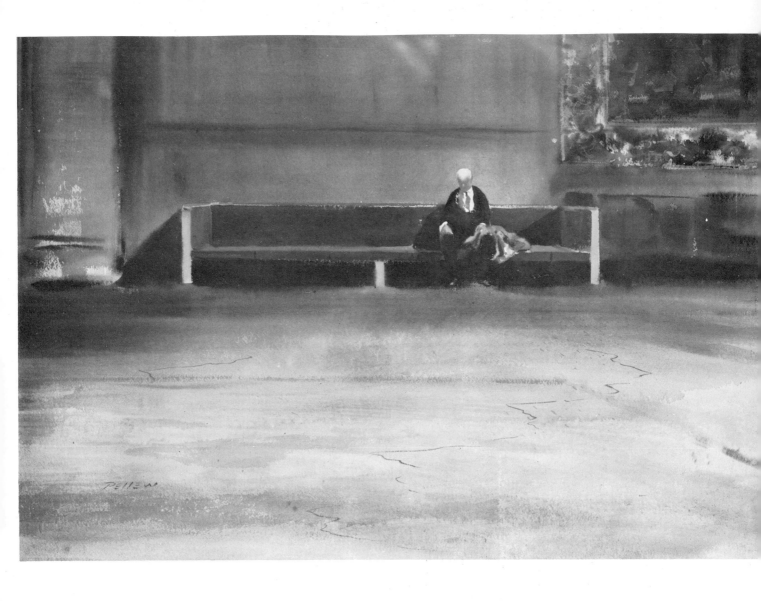

**Museum,** watercolor on paper, 21″ x 27″.

*A single figure in a large, empty space—I think that's what gives it its dramatic impact. If the man and the corner of the bench filled the picture space, the mood wouldn't carry with the emphasis it now has. One afternoon, after wandering around the galleries of New York's Metropolitan Museum, I sat on a bench to rest. Looking across the main lobby to the opposite side, I saw my picture. Even before I put pen to paper, I knew I couldn't miss with this one. The original sketch, drawn with a ballpoint pen, is reproduced. I made only two changes in the composition when I painted it. One was to put the man nearer the corner of the bench; the other was to make the bench taller and not quite as long as it appears in the drawing. The lightest lights are the man's shirt front and the top of his bald head. The darkest dark is his black suit. The bench is covered in a ruby red material. Walls and floor are a warm brown-beige, the tapestry in the upper right is faded gold.*

*Sketched with a ballpoint pen in New York's Metropolitan Museum, this drawing, plus a good visual memory, produced* Museum.

When I'm asked which of my museum interiors is my favorite, I have to admit that it's *Museum*. Painted from a sketch made at New York's Metropolitan Museum of Art, it was exhibited and won an award at the American Watercolor Society annual in 1959. It was sold from that exhibition. I wish I knew who owns it. I have no record. The little man asleep on the long bench was just too good to miss. I know his feet were killing him. He never knew that by sitting on the bench to rest, he gave me the opportunity to paint one of my best watercolors. Good luck to you my friend, wherever you are.

## Closeups of the Woodland Floor

A closeup painting of the floor of the woods isn't everybody's cup of tea. An artist friend of mine calls them "photographers' subjects." I don't agree. He's the kind of painter who likes to paint picturesque peasants—and that's what *I* call a photographer's subject.

As I walk through the woods, I see a lot of paintable material. For instance, a fallen tree branch, partly covered with colorful patches of fungi, can be a beautiful thing. So can an old tree stump, with most of its bark rotted away, and speckled with woodpecker holes; or a gray rock, peeking through last autumn's fallen leaves, its cool color enhancing and complementing the warmer tones surrounding it. These are *all* good subjects. And in the spring, there are the wild flowers, and they're the best of all.

The floor of the woods. *A drybrush drawing of a fungus-covered branch, picked up in the woods, shows just one of hundreds of interesting things that nature provides for the artist who has eyes to see.*

123

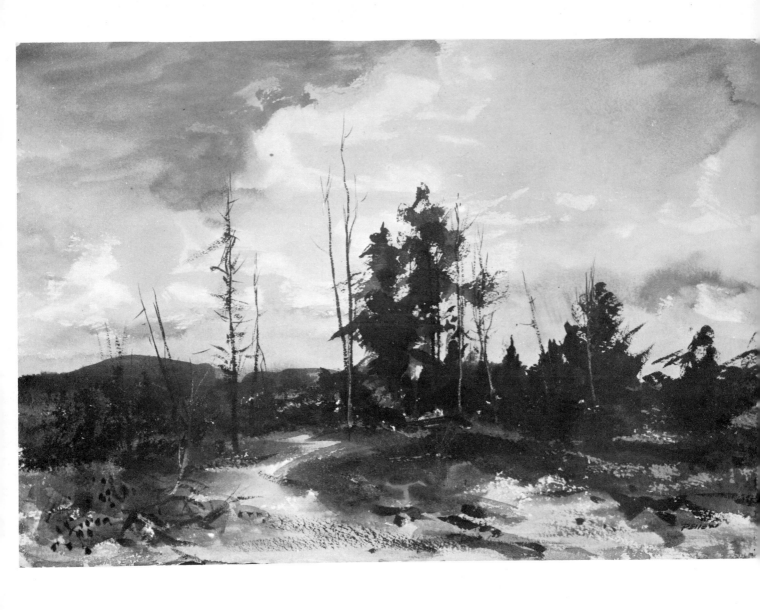

**New Hampshire Silhouette,** watercolor on paper, 15″ x 20″.

A bright summer day at the top of a mountain trail. Although it appears calm and peaceful, it was painted under trying circumstances. Black flies and midges were swarming like fury around my head and hands in spite of the repellent I had doused myself with. The joys of landscape painting! But I've discovered that some of my watercolors painted outdoors under adverse conditions turn out to be good ones. I suppose it's the speed with which they're executed that does it. Watercolor demands spontaneity. I know there are always exceptions to the rule, but it's generally the swiftly painted watercolor that reveals the distinctive charm of the medium. In this painting, notice the play of dark against light: the deep darks of the evergreen trees against the brilliant cloud formation. Notice also the light pattern, starting in the right foreground and leading the eye into the picture's middle distance. This painting progressed from light to dark. I used broad, bold washes, as well as some drybrush directly on the dry paper.

**September Weeds,** watercolor on paper, 22″ x 30″.

*It would be quite impossible to forget painting this one. The insects almost drove me out of my mind. However, I think it was worth it. I was first attracted to the spot by the bright yellow spikes of goldenrod, seen here just to the right of center. In the upper left, there are the remains of some Queen Ann's lace. The beaten down, long, light colored stalks probably mark the passing of some child or animal. The whole thing presents the effect of a richly textured tapestry. To get really close to my subject, I sat on the ground among the weeds. I guess that's what stirred up the insects, for from then*
*on it was a race between them and me to see if I would get out of there alive. I started this picture by rubbing in some brown and green tones as a background over which the more definite weeds would be painted. Opaque color was used in many parts of this painting—also scratching and scraping with a razor blade, as well as with my fingernail. In doing a subject of this kind, you must think primarily of design and balance. Unless you do, the result may be nothing more than mere confusion. Everything went into this particular painting— even some dead insects.*

125

*Students who make careful drawings of grasses and weeds will have greater confidence than the non-sketcher when it comes to painting such subjects rapidly into their watercolors. This was drawn with a No. 0 brush and drawing ink diluted with water. Collection, Mr. and Mrs. George McDonald.*

My painting, *The Wild Bloodroot*, was painted in our own little wild garden at the edge of the woods. I sat on the ground to do it. You have to get next to your subject when you do this sort of thing. These dainty flowers push their way through the matted oak and beech leaves very early in the spring. I watch for them every year. When they begin to show their curled up buds above the ground cover, I know that winter is over. This is one of the compensations of the New England climate—things are constantly changing. Each month has a different look than the one preceding it. For the artist and woodsman, there's even a difference between January and February, believe it or not. It's all beautiful and it's all free!

**The Wild Bloodroot,** watercolor on paper, 9″ x 12″.

*My wife's wild garden has been the inspiration for several closeup subjects. This study of the dainty bloodroot is one of my favorites. Sitting on the ground with my board against a rock, I first drew the two flowering plants and the two younger ones below them. This was the only pencil work. The entire background was then covered with gray tones, using mixtures of burnt umber, thalo blue, and gouache white. These tones were scrubbed on with an old, well-worn round sable brush, and with no attempt at details. Next came the brush-work, suggesting the leaves of oak and beech that partly cover the ground. The oak leaves are painted in faded reds, the beech leaves in dull yellows. Next came the bloodroot plants themselves. For their curled green leaves, mixtures of yellow ochre, a little thalo blue, and white were used. The white flowers were the last to be painted. Pure white paint was used for their lightest parts, and white with a very little thalo blue and light red to create a delicate shadow tone. The paint throughout is quite opaque. There are no transparent passages.*

## Working on the Spot

I think the best paintings of this kind of woodland subject are those done on the spot. The more finished, elaborate pictures, painted in the studio from sketches, never seem to come off as well. They're usually stiff and overworked, lacking the fresh, spontaneous quality of those done outside.

I keep these paintings quite small. A quarter sheet (11″ x 15″) is large enough. The little plants can then be painted close to actual size. They look best that way. I sometimes do them in transparent watercolor, but more often I use opaque. The bloodroot painting is opaque.

My procedure was as follows. I first drew the white flowers, using an HB pencil with a nice, sharp point. Nothing else was drawn. The entire background was then covered with gray tones, using mixtures of burnt umber, thalo blue, and white gouache. Into this—even before it was dry—I started suggesting the beech and oak leaves that lay on the ground around the little bloodroot plants.

The beech leaves were dull yellows, for which I used yellow ochre, raw sienna, and a little burnt sienna. The dry oak leaves were painted with red tones, grayed with white. The red was Winsor & Newton's light red.

Next came the plants themselves. For their curled green leaves, mixtures of yellow ochre, a little thalo blue, and white were used.

The white flowers were the last thing to be painted. I used pure white paint for the lightest parts; to create a delicate shadow tone, I also used white, to which a *little* thalo blue and light red were added.

The paint was thickly applied throughout. There are no transparent passages. Only round sable watercolor brushes were used.

I've said elsewhere that you shouldn't carry a still life approach to nature. This type of subject is the exception. It can—and should—be treated as still life, with more concern for detail than there would be in painting landscape.

So don't scorn what my friend calls a photographer's subject. Look around you for closeup material. It doesn't have to be growing things or even the floor of the woods. Inanimate objects—especially worn ones, such as old, battered buckets, farm or garden tools, barrels, a weathered hank of rope, or a broken lobster trap—are a few things that come to mind. However, they must be painted as found, never moved or arranged. That's the charm of the closeup—the intimate, natural quality. These little pictures seldom make good exhibition pieces, except in a one-man show. They make charming decorations, however.

## Learn to Paint by Painting

That's about it. We've wandered through the wonderful world of watercolor, exploring techniques and subject matter. I hope it's been a pleasant and worthwhile journey for you. Remember that you learn to paint by painting. So put away those golfclubs, fishing rods, and sailboats—and paint!

# Demonstrations

**The Salt Marsh:** Step 1.

*First I took an HB pencil and lightly drew a line indicating the horizon or eye level. (This would be at the base of dark pine trees.) Now, if you wish, you can put a wiggly line where the tops of these trees will come; this is to keep you from making them too tall when you paint. Watch their proportion in relation to the rest of the picture space. Next, I drew the shape of the foreground marsh: only the big shape, not the detail. Now I was ready to begin painting.*

*I began by wetting the sky area with clean water, using a 1" flat brush. I mixed a puddle of Payne's gray and, with the same brush, I rapidly painted the cloud formation onto the wet paper. (Remember that Payne's gray dries much lighter than it appears when wet.) I used rapid horizontal strokes, twisting the brush to obtain some variety. I kept the sky lighter toward the horizon and I let the sky dry before painting any of the land areas.*

*The dark mass of the pine woods was the next to go in. I used a mixture of our two colors with much more Payne's gray than raw sienna. The brush I used was a No. 8 round sable. (It could also be done with oxhair.) Notice the drybrush texture left to break up the dark mass. This was washed over later. The treetops against the sky were done with rapid upward strokes of the same brush.*

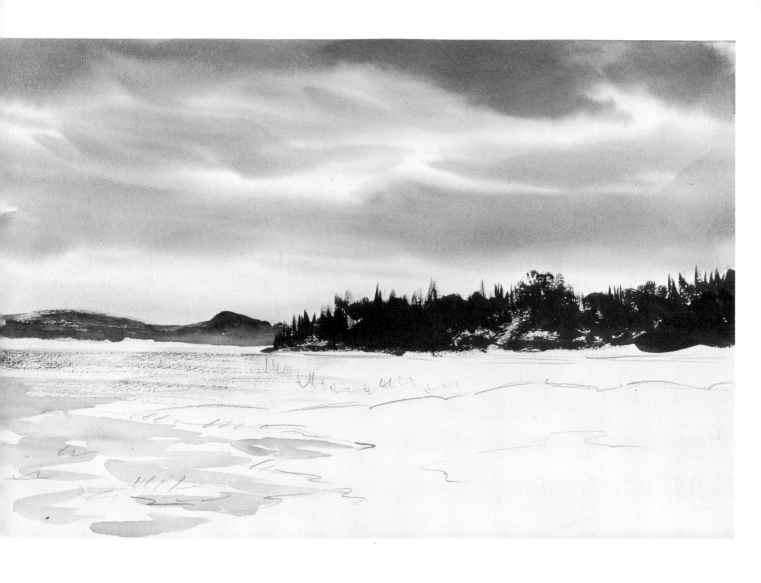

**The Salt Marsh:** Step 2.

*Next, I painted the water, using the same mixture (Payne's gray) as used for the sky, but this time painting directly on dry paper. Note the drybrush to suggest sparkle on the distant water, and the bolder strokes in the foreground. The brush I used was my favorite 1" flat. The distant land to the left of the dark pines was put in, with the No. 8 round brush, using raw sienna only. Although it was simply painted, it has some variety of tone and texture. Notice the drybrush at the extreme left and the dark hump nearer the pines.*

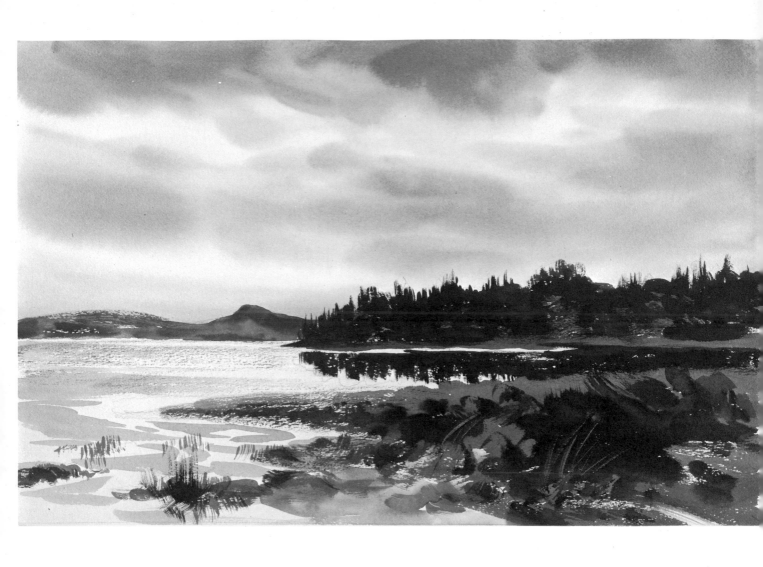

### The Salt Marsh: Step 3.

*The dark tree mass having dried, the white drybrush parts were now given an over-wash of diluted Payne's gray. (This must be done rapidly in order not to disturb the dark undertone.) I used a large brush—the No. 8 will do—and a light touch. (Don't go back over it.) I mixed a green with the two colors and put in the strip of grass at the base of the trees. Now, with pure Payne's gray, I put in the trees' reflection in the water, leaving the streak of light along the shore line.*

*The final step is the foreground marsh grass. Starting just below the tree reflection, with plenty of raw sienna on the brush, the middle tone of the marsh was put in. Toward the bottom edge, the brush was dipped in water and the light tone, suggesting a sandy area, was indicated. With a dark mixture of our two colors, the darks of the foreground were put in. This is made up of stabs, blobs, and drybrush, all rapidly done with the No. 8 brush. (Unless painted swiftly, the area will lack life and character. Don't worry if you fail to match my darks exactly; working at top speed, it will be impossible anyway.) A few fingernail scratches were made in the wet paint in the right foreground, and the brush was spread fan-like on the palette, then used with an upward stroke to create the fine vertical lines in the left foreground.*

*That's it. We've painted a Maine salt marsh. Just a moment! There's a bird coming over the treetops. Put it in—it helps to set the scale of the place.*

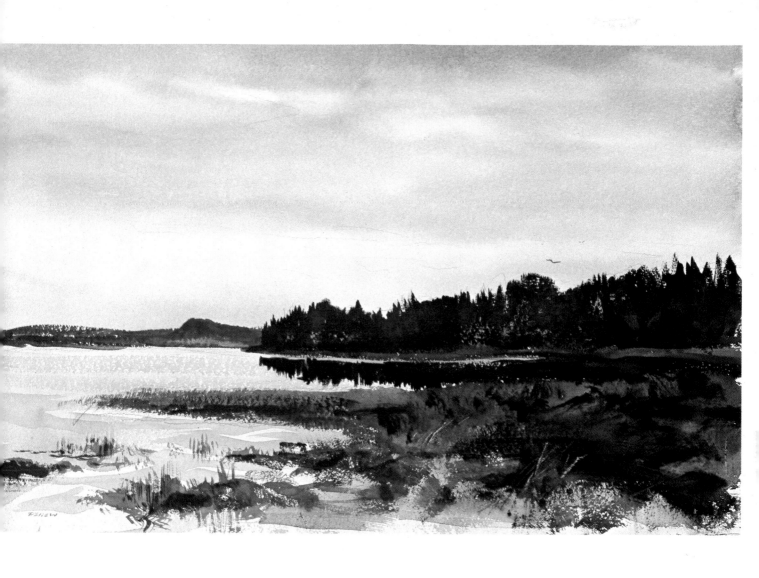

**The Salt Marsh,** final stage, watercolor on paper 15″ x 22″.

*I've always worked with what's called a limited palette. I don't believe that good color is obtained by the average painter by using fifteen or twenty different colors. A born colorist can pull it off. But the born colorist is a very rare animal indeed. I seldom use more than four or five colors in a picture, although I carry ten in my outdoor painting kit. I don't think* The Salt Marsh *above is lacking in color appeal and you* know *it was painted with only two colors. The key to good watercolor technique is simplicity—and that goes for color as well as the rest of it. Simplicity isn't easily come by. Keep it in mind constantly. I'm sure this salt marsh wouldn't look any better if I'd used a dozen colors in painting it. Let's say it's a simple subject simply stated, and that's what all good watercolors painted outdoors should be.*

**Edge of the Woods, Winter:** Step 1.

*The first all-important step in any watercolor is putting down those few lines with which we design the picture space—the composition. I tell students over and over again that neither color nor tricky brushwork will save a bad composition. Although my composing was done merely with a brush and some burnt umber, and it's quite sketchy, I did give it some thought. The snow-covered foreground slants from above center on the left to below center on the right. This avoids a too obvious central spatial division, cutting the composition in half. The large treetrunk on the right was moved in from further over on that side. I needed it as a balance for the large, dark evergreen on the far left. A few lines to indicate the treetops, the field gate, and the pointed fir beside it, and I'm ready for the first washes.*

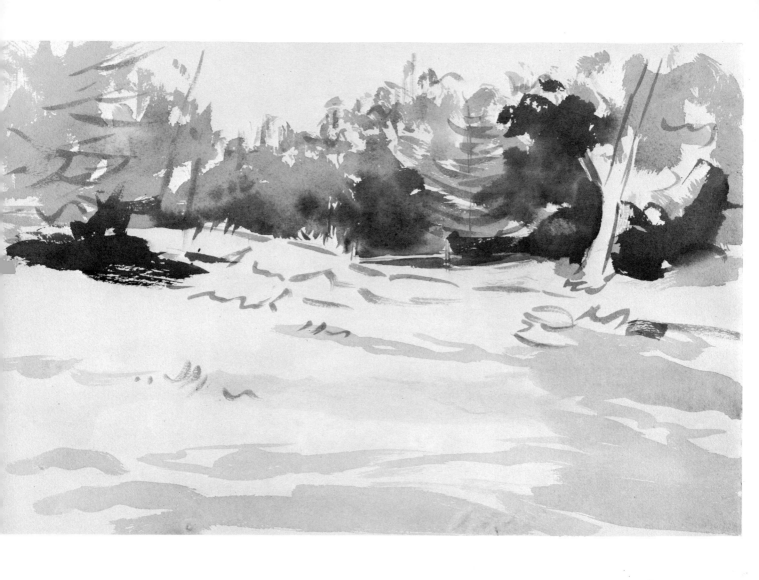

**Edge of the Woods, Winter:** Step 2.

*The middle tones of the wooded background were the first to go in. These were the color washes over which the darker tones will be painted. (Most of my watercolors are painted from light to dark.) The cool colors in this step were obtained with mixtures of cerulean blue and Payne's gray; the warm grays with burnt umber and a little thalo blue. A pale wash of Payne's gray was used for the cast shadows in the foreground. Notice that I carefully painted around the crossbar of the gate, leaving white paper.*

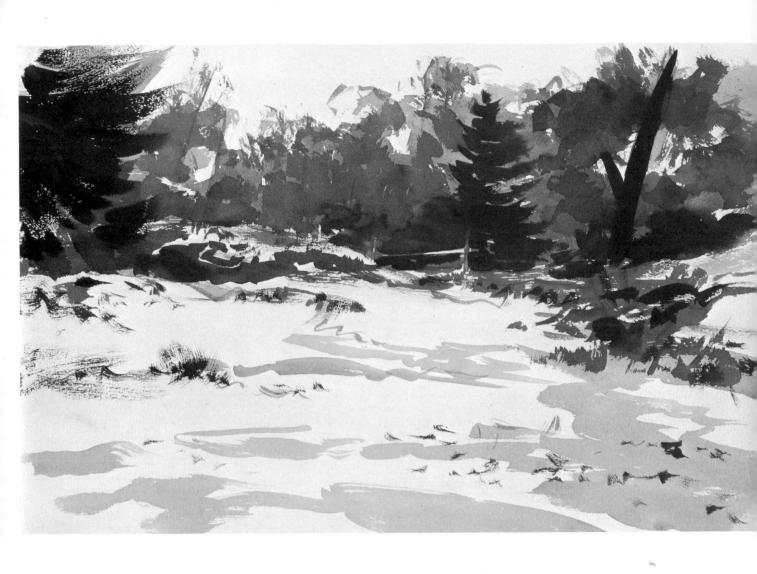

**Edge of the Woods, Winter:** Step 3.

*Now came the step that makes or breaks a watercolor—putting in details that won't spoil the beginning. With a mixture of thalo blue and a touch of raw sienna—and plenty of paint on the brush—I put in the big spruce on the left. Adding more raw sienna to obtain a rich dark green, I painted in the fir tree just beyond the gate. Some of the background values were deepened, using the same colors as before (see Step 1), and the dried, brown grasses along the edge of the woods, from left to right, are put in with mixtures of raw sienna, burnt sienna, yellow ochre, and burnt umber.*

*The next move, and the final one, was painting in bare branches and treetrunks. As you can see, I started with the big tree at the right. Some of the trunks and branches were painted with pure Payne's gray and burnt umber. These, along with the few lights scratched out with a razor blade, can be seen in the color reproduction.*

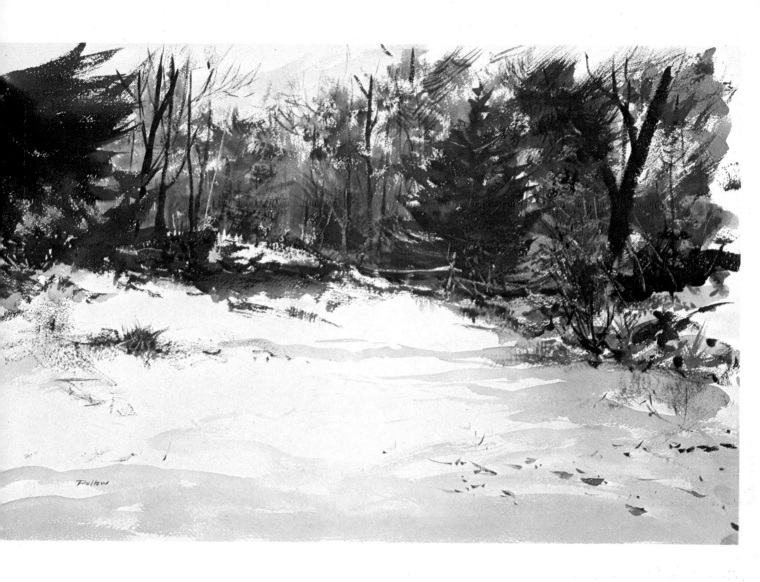

**Edge of the Woods, Winter,** final stage, watercolor on paper 22″ x 30″.

*Walking along the edge of the woods after a heavy fall of snow, you can almost feel the quiet. There's a hush over everything. Even the birds are still. Snow, falling from an overladen evergreen tree, reaches the ground with an impact so soft that it's almost a whisper. Yes, there's a quiet dignity about winter. The difficulty about painting it is in avoiding the typical Christmas card approach. A snowscape is a thing of beauty. It's a pity that so many amateur painters make it merely pretty. You don't need a lot of subject matter to make a good winter landscape. Forget about that covered bridge or the little cottage with the green shutters and the lamp in the window. Just paint a slice of nature. It could be done with an old treetrunk that has freshly fallen snow clinging to its rough bark. Or take in a broader view and paint something like the picture reproduced above.*

*Paint the beauty of nature, but don't get cute or pretty. If you work from photographs, take them yourself and use black and white film. Trust your memory for color. You'll make a more personal statement that way. Color photographs, unless taken by an expert, aren't true to nature anyway. Learn to appreciate the strength and beauty of simplicity as I did in this edge-of-the-woods snowscape.*

**Golden October:** Step 1.

*The first thing I did was to position the figure. This was indicated with a few pencil lines as seen here. No other drawing was done prior to painting. The paper was then placed in the bathtub and allowed to soak for twenty minutes. I wanted to paint an impression of the mellow, golden glow of the October woods, not a literal rendering of the scene. I thought a wet watercolor would be the best way to do it. When the paper was lifted out and placed on the glass top of my studio drawing table, I floated in the first light tones. For these I used gamboge yellow, yellow ochre, raw sienna, and cadmium scarlet. No thought was given as yet to the treetrunks, branches, or the suggestion of details.*

**Golden October:** Step 2.

*More of the same came next—but picking up more paint on the brush to deepen the tonal values. I began now to establish a pattern. This has always been my procedure when painting wood interiors. I create a color pattern of lights and darks long before I start thinking of the details. I call this the abstract stage. Allow me to repeat that even the most realistic picture should be based on a good abstract pattern or design. The paper was still very wet and the colors blended together softly. I kept the paint from running into the figure by blotting with tissue.*

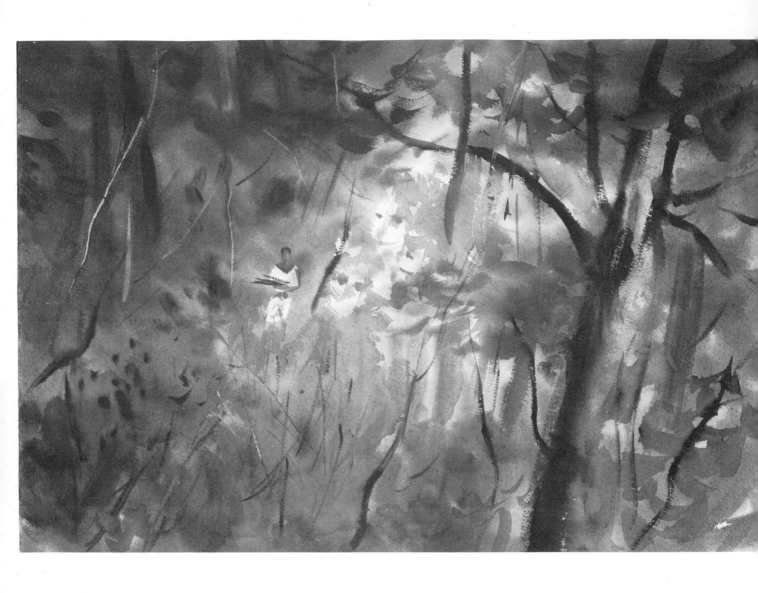

**Golden October:** Step 3.

*The forest began to take shape. More darks were added, using the colors mentioned, but with burnt umber added to the darker areas. The head, shoulders, and arm of the figure were painted in with a mixture of burnt sienna and yellow ochre. The branches she's holding were indicated with burnt umber and the light area to the right of the figure was blotted with tissue.*

*I was now ready to consider the treetrunks, branches, and whatever detail I felt should be suggested. With my brush loaded with thick burnt umber, I started placing trunks, etc., where I thought they worked as a well-balanced design. Remember that I was working from memory. After viewing the scene from my window, I turned my back on it. I felt that this was necessary to retain my vivid first impression. The final touches that completed the picture can be seen in the color reproduction.*

**Golden October,** final stage, watercolor on paper 20″ x 28″.

*I don't think there's any doubt about this being a very wet watercolor. It should be. The paper was soaked for at least twenty minutes and the picture was completed as you see it here before the paper had dried out.*

*The woods behind my studio have been the inspiration for many paintings done at all seasons of the year. Fred Whitaker, a neighbor of ours before he moved to California, once called this patch of woodland "Jack Pellew's goldmine." Well, it's hardly been that, but I do find it interesting and lovely to look at.*

*If this one teaches the student anything, it should be that you don't have to paint details to convey the impression of thick woods, trees, branches, twigs, etc. A good watercolor isn't necessarily a copy of nature. A painting is first a product of the imagination. (I think Degas said that.) One October morning, when the trees were all ablaze with that famous New England autumn color, I saw my daughter Elma walking through the woods and I knew another picture had arrived. Call it inspiration or, in the language of today, say that I'd been "turned on." The figure, although merely suggested, provides a focal point and sets the scale of the scene. I tried to hold onto my first impression. I don't always make it. This time I think I did.*

**The Little Street:** Step 1.

*A street scene is one subject that often demands a vertical composition. Most land-scapes, even those containing tall trees, lighthouses, or church steeples, compose best in a horizontal shape. In selecting this subject, it was the outside fire escapes on the right that caught my eye. Being in shadow, they made a nice dark note against the sunlit buildings behind them. My first step was the drawing shown here. I drew directly with the brush, using burnt umber diluted with water. (The beginner should make small pencil roughs for composition before going this far.) Notice that I've outlined the cast shadows on the road. I knew their shape would change before I finished painting. I wanted them as I first saw them.*

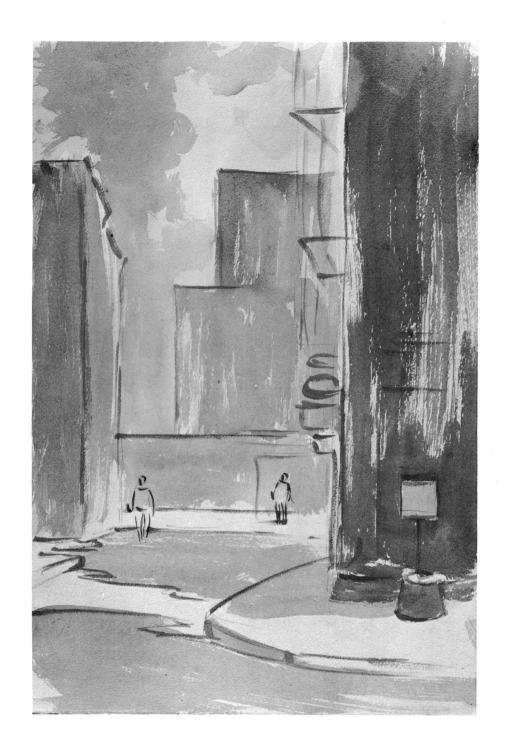

**The Little Street:** Step 2.

*The first light color washes came next—more to establish the composition than anything else. For the cool color in the sky, I used Payne's gray, leaving the cloud almost pure white paper. The more distant buildings were given washes of yellow ochre and cadmium red. The sunlit parts of the road and sidewalk received a pale wash of yellow ochre. The foreground building and the one at the left were given washes of burnt umber. This was intended as a warm undertone, to be gone over later with cool color. The cast shadows in the road were treated in the same manner—also with burnt umber.*

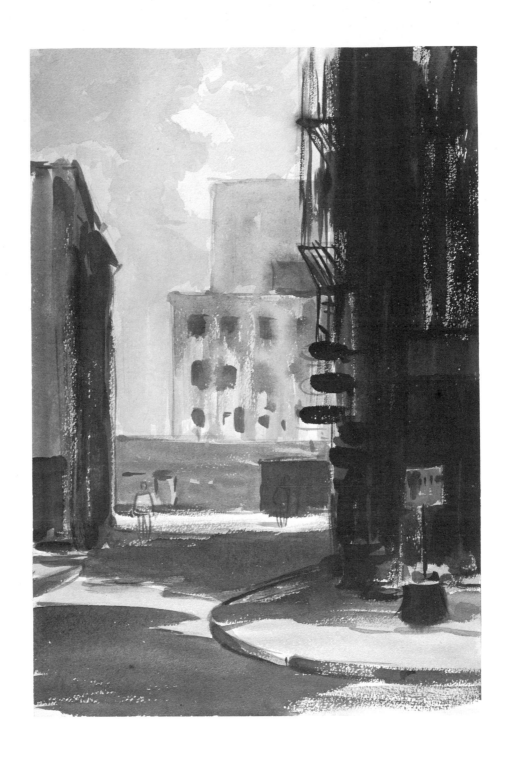

**The Little Street:** Step 3.

*Now the picture really began to take shape. Some strong definite darks went in on the right side. These were done with a fully loaded No. 8 round sable, dipped in Payne's gray—just enough water in the brush to make the paint flow. A transparent wash of this same color now went over the cast shadows. This was done rapidly in order not to pick up the underpainting. From now on, it was a matter of deepening the values and deciding how much detail to suggest. The final result is seen in the color reproduction.*

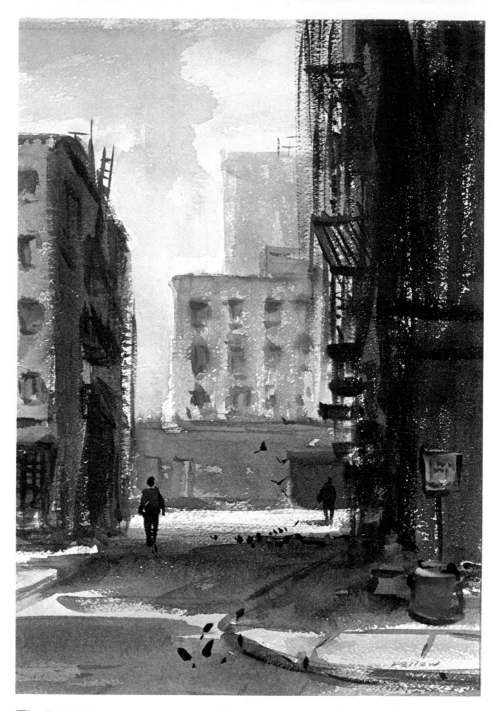

**The Little Street,** final stage, watercolor on paper 11″ x 15″.

*In Chapter 7 I described how I paint street scenes in the studio from pencil sketches made on the spot. The picture reproduced here is an exception. It was painted from start to finish on the street. This was possible because the locale is lower Manhattan on a Sunday morning—the part of New York City deserted on that day. There's a strange mixture of old and new buildings in this small area. The old are rapidly disappearing and those which replace them lack the charm of the weathered brick warehouses with the outside fire escapes. You'll notice that there's a suggestion of life here: two simply painted figures and some pigeons. I'm strongly in favor of getting some life into every street scene. One without figures is incongruous. Yet amateur painters often paint pictures of streets without a soul in sight. This is because they're afraid to tackle the figure. In Chapter 7 I tell how this fear can be overcome. Simplification must be kept in mind if your street scene is to be a painting. It can easily turn into an architectural rendering if you don't. Study my painting carefully and notice that although it's a realistic handling of light and shade, there's really very little detail in it.*

**Dragger Ashore:** Step 1.

*In Chapter 8, I told how I made the original drawing of this Gloucester fishing boat. The drawing here isn't that original, but the first step taken when I painted the picture. The important thing is the placing of the boat and its size in relation to the picture space. Note that the boat's hull is below and to the left of center. When this pencil drawing was completed, the paper was put in the bathtub to soak under water for twenty minutes.*

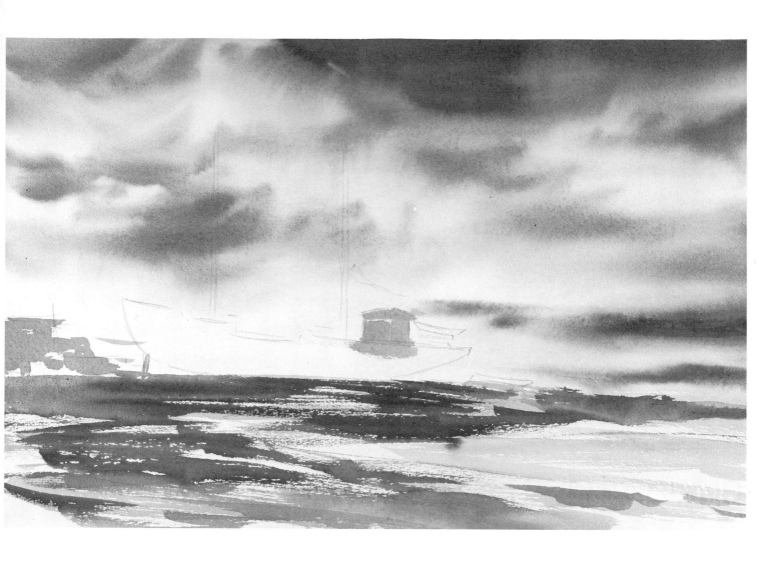

**Dragger Ashore:** Step 2.

*The sky was painted all at one go. That is to say, it was completed before going on to any other part of the picture. For the warm gray tones, I used mixtures of Payne's gray and light red. On the right side, there are some touches of gamboge yellow and near the horizon a fairly strong band of thalo blue. The wheelhouse was the only part of the boat painted as I wanted to establish its value against the sky. Some tones of burnt umber mixed with Payne's gray were now painted in the foreground below the boat.*

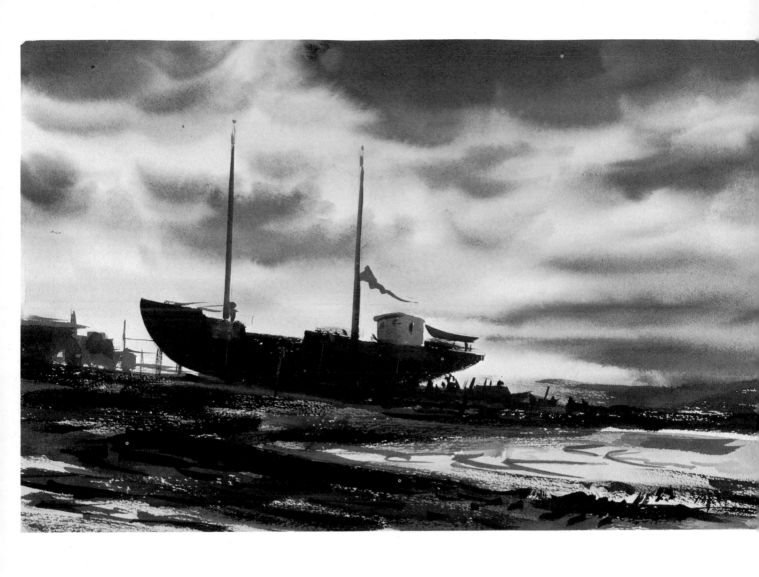

**Dragger Ashore:** Step 3.

*Now I began to consider detail. I worked on the boat, painting its hull with a mixture row sienna, burnt sienna, and Thalo blue to obtain a rich, dark green. The masts and the dory on the stern went in along with mere suggestions of some other things I don't even know the names of. Some dark tones were added to the shore and a warm yellow and some burnt sienna were washed over some drybrush just below the center of the boat. The picture was almost complete. A few finicky details, such as the rigging and the little foreground figure, were the last to go in.*

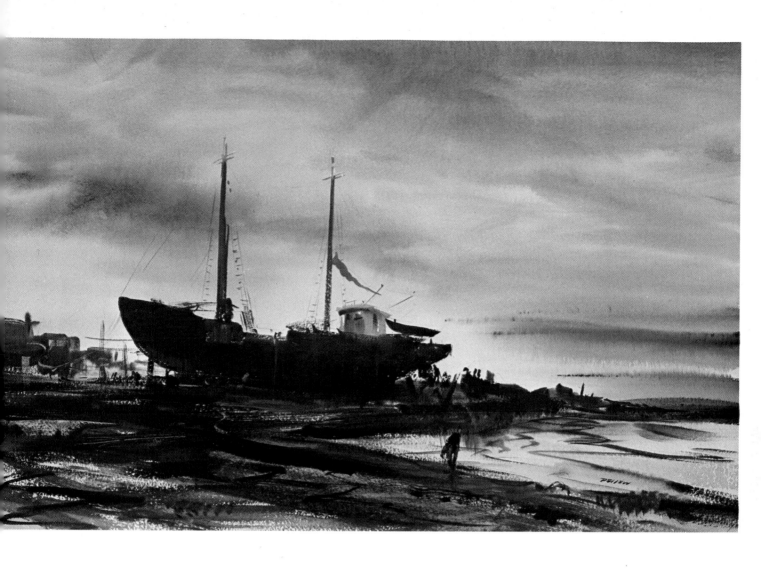

**Dragger Ashore,** final stage, watercolor on paper 15″ x 22″. Collection, Mr. and Mrs. Joseph Chickvary.

*The Gloucester fishing boat has been a favorite subject with the summer vacation painter for a long time. The boats are picturesque, with their nets, gear, and graceful, curved bows. They make a pretty picture when one or more are tied alongside the wharf. That, of course, is exactly what's wrong with it as a painting subject. It's been done to death. In the past twenty years, there have been thousands of pictures painted of the green boat with a red stripe at the waterline, blue water and wiggly reflections of boat and masts reaching down to the foreground. These boats along the wharf have been painted so often that they (and the covered bridge) have become art's number one cornball.*

*This painting is of a typical Gloucester fishing boat, but it's not the typical Glouces-ter picture. In Chapter 8, I told how I discovered this subject. The lesson to be learned here is that you should not be too willing to accept nature "as is" and that nature seldom presents us with a ready-made composition.*

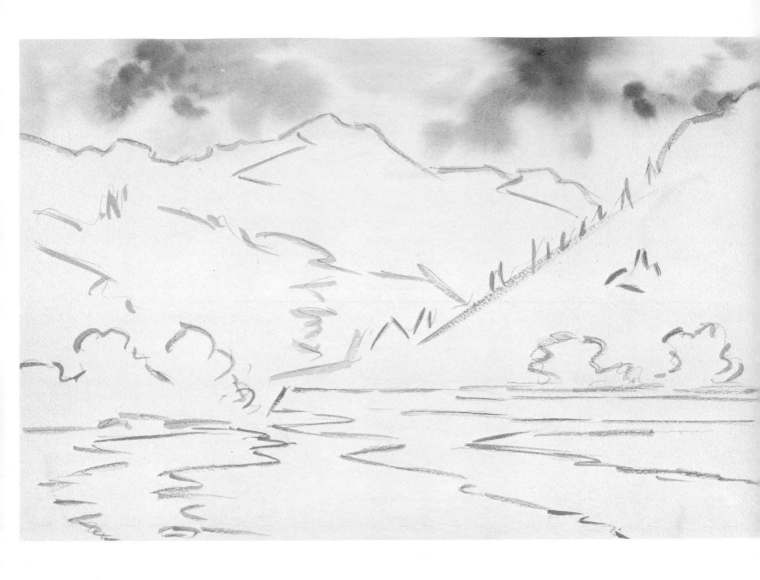

**The Little Cimarron:** Step 1.

*The first step is always the composition—the designing of the space within the four borders of the sheet. As a rule, I first establish my horizon or eye level, keeping it well above or well below the center of the picture space. Here it's the long horizontal line of the river's far bank.*

*I sketched in the composition with some diluted burnt umber, using a round sable No. 5. Until you're experienced, you'd better use a pencil. However, don't use the eraser too often. It can damage the paper's surface. The drawing done, I painted the clouds and the patches of blue sky. Thalo blue was the only color used.*

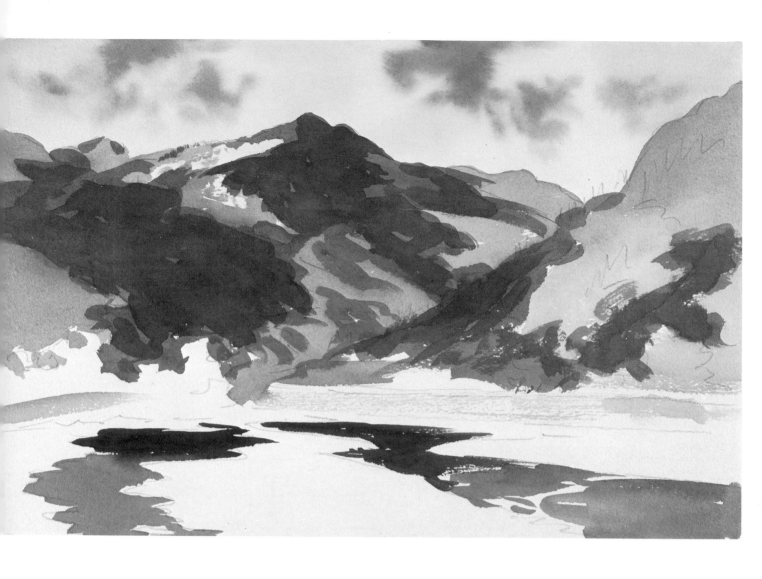

**The Little Cimarron:** Step 2.

*The distinct mountain was sparkling in the sun, its detail as distinct as the rocks and pebbles at my feet. Paint them both with equal emphasis and the picture would have no depth. It's sometimes necessary to take liberties with nature, and that's what I did. By putting clouds into what was actually a clear sky, I had an excuse to use cloud shadows on the landscape beneath. They can be seen as large, dark patches. In the foreground, the shallow areas of water and the uncovered rocks and pebbles have all been indicated. No details as yet.*

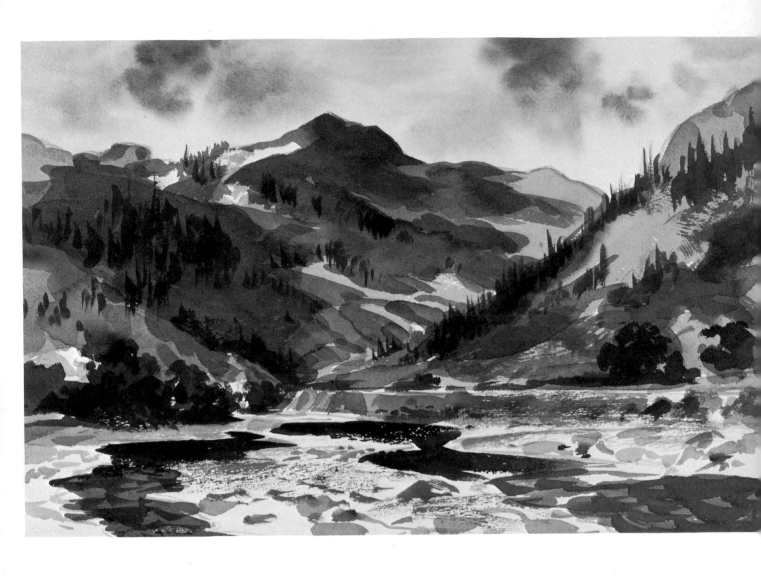

**The Little Cimarron:** Step 3.

*The problem now was to add just enough detail, then stop—never easy when painting from nature. In this illustration, you see the picture almost finished. I've put in the trees on the mountainside and on the river banks. If they don't quite match those in the color reproduction, don't be too critical. This is a reconstruction of my painting procedure, painted many months after my return from Colorado.*

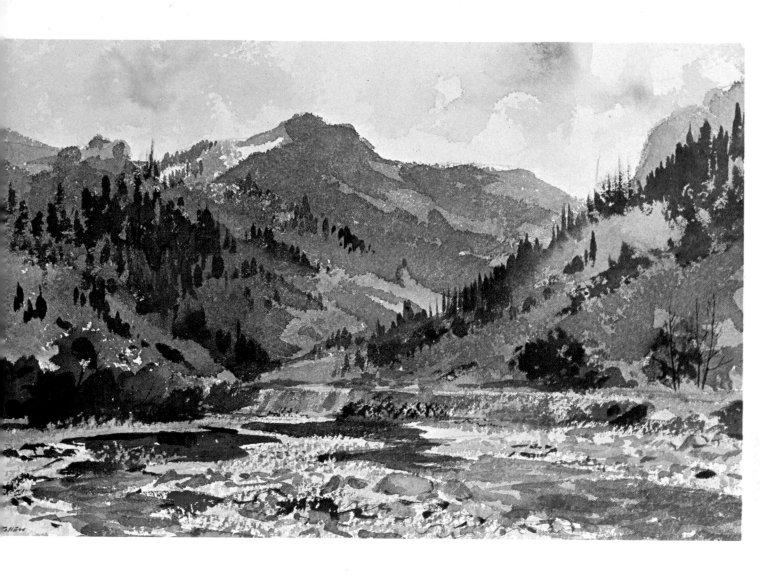

**The Little Cimarron,** final stage, watercolor on paper 7½″ x 11″.

*Here you see the finished painting. It's a good likeness of the place, even though I had to take liberties with the actual tonal values. As you can see, all the sparkle has been kept in the foreground. The cloud shadows on the mountainsides, being simple in treatment and cool in color, help to create an illusion of recession. This feeling of depth didn't really exist in the scene before me. At high altitudes, the air is thin. The details on the mountain, miles away, were as clear as those of the foreground. Even the realistic painter doesn't merely copy nature. That day on the Little Cimarron, I knew that a literal copy of the values, as I saw them, would result in a flat picture. So I made the changes I've outlined—and it was the right thing to do. Although this is a small watercolor (an eighth sheet), I don't think the bigness of the mountains has been lost. In fact, the simple washes give the mountains greater solidity than they appeared to have in that brilliant, clear light.*

**Viewing Constable:** Step 1.

*On the dry, white paper, I drew the subject in pencil. This was merely an outline drawing; no attempt was made to put in any details. I was concerned only with composition: the design of the picture space; the arrangement of the major elements within the four borders of the paper. When the pencil outline was completed, the paper went into the bathtub for a ten-minute soaking. It was then lifted out and placed on a glass-covered drawing table. The surface water was blotted up with a soft towel. The first color washes now went in. They were put in with a ¾" flat sable brush. The colors used for these first light washes were yellow ochre, cadmium scarlet, and burnt umber. They were brushed together on the wet paper and allowed to blend softly. On the left is the original sketchbook drawing for the figure I used in Viewing Constable.*

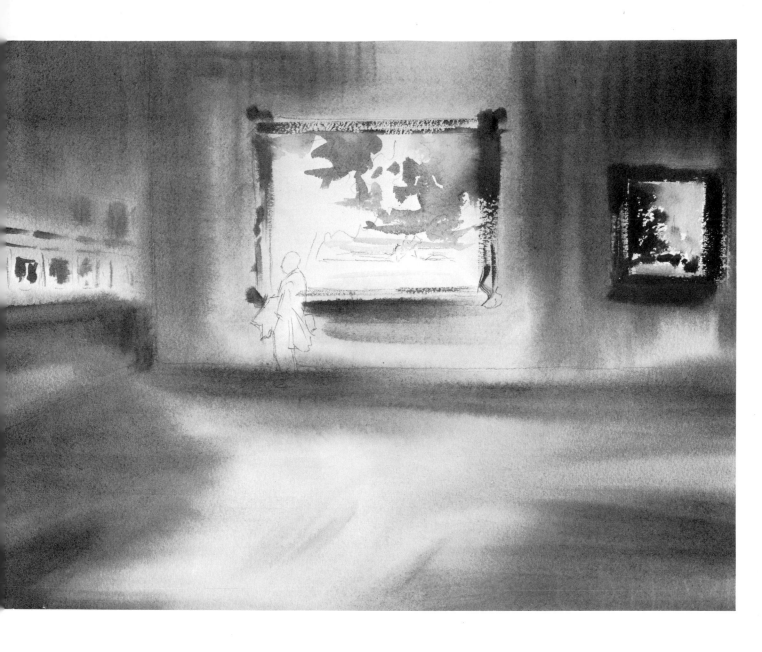

**Viewing Constable:** Step 2.

*I strengthened the pattern. Darker tones went into the floor and walls, using the same three colors I used at first. (To obtain darks on wet paper, plenty of paint must be picked up on the brush. Remember that watercolor always dries out lighter in value than it appears when wet.) I next did some work on the pictures hanging on the walls. In the large central picture, I put in some of the blue tones of the sky and started on its gold frame. For the frame, I used yellow ochre, raw sienna, and burnt umber. For the dark frame on the right, I used a mixture of burnt umber and Payne's gray. Some dark greens and some sky tones were roughly indicated within the frame to establish the composition of the Constable painting. Then, over on the left, I started to develop the double line of sketches hanging there. Still nothing done on the figure.*

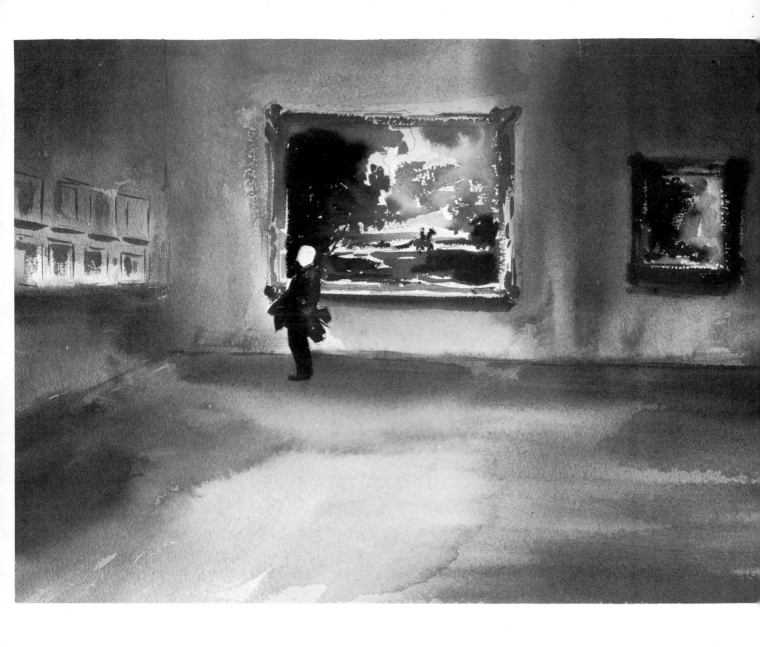

**Viewing Constable:** Step 3.

*The picture was almost finished at this step. As the paper was still quite wet, I was able to darken the left wall and the floor on that side without leaving any hard edges. I used Payne's gray (a cool color) over the warm red-brown underpainting. The right side of the back wall was also darkened with this color. I next finished the paintings and their frames. Note how the bright lights on the lower part of the large frame carry your eye to the figure. All this time, I'd been working at top speed. Now some time was taken out to allow the paper to dry a little—the reason being that I needed some sharp edges on the figure, which was the last thing to go in. Notice the simple treatment of the clothing. With the painting of the man's head (see the color reproduction), the picture was finished. How long did it take? Exactly two hours' painting time.*

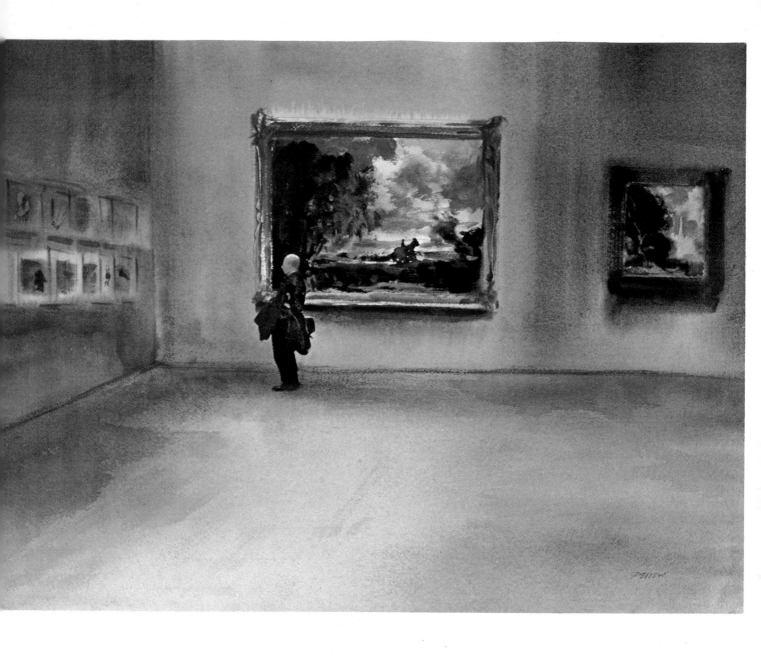

**Viewing Constable,** final stage, watercolor on paper 21″ x 27″.

*Inspiration for the painting came during a visit to London's Victoria and Albert Museum, which houses a great Constable collection. The red walls of the gallery, the gold frames, the rich browns, blues, and greens of the paintings, all make a handsome combination. A pencil sketch and some notes were made on the spot. For a single figure, I made use of a drawing I made at the New York's Metropolitan Museum.*

*I believe a painter paints best the subjects he knows best. However, there are times when something outside familiar surroundings creates such an impact that it demands recording. Thus did this watercolor emerge from an hour spent in a museum 3,000 miles from home.*

*This is a "wet" watercolor, painted in the studio. I soaked the paper until it was thoroughly wet clear through. My painting procedure was to start with the lightest tones and finish with the darks. The painting won the First Watercolor Prize in the 1963 Midyear Exhibition at the Butler Institute of American Art, Youngstown, Ohio. It is now in the permanent collection there.*

# Bibliography

Here are a dozen books on watercolor history and technique that I've enjoyed.

*Early English Watercolour* by C. E. Hughes, Ernest Benn Ltd., London, 1950.

*English Watercolour Painters* by H. J. Paris, William Collins, London, 1945.

*English Watercolours, Turner, Girtin, Cotman, Constable and Bonington.* With an introduction by Laurence Binyon. Oxford University Press, London, 1949.

*A History of British Watercolour Painting* by H. M. Cundall, Charles Scribner's Sons, New York, 1929.

*Winslow Homer Watercolors* by Donelson F. Hoopes, Watson-Guptill Publications, New York, 1969.

*The Life and Art of Thomas Collier, R.I.* by Adrian Bury, F. Lewis Ltd., London, 1944.

*More Than Shadows, A Biography of W. Russell Flint* by Arnold Palmer, The Studio Ltd., London, 1944.

*XIXth Century Drawings and Watercolors* by Jean Selz, Crown Publishers, New York, 1968.

*100 Watercolor Techniques* by Norman Kent, Watson-Guptill Publications, New York, 1968.

*Two Centuries of British Watercolour Painting* by Adrian Bury, George Newnes, Ltd., London, 1950.

*Turner Watercolours* by Martin Butlin, Watson-Guptill Publications, New York, 1968.

*Watercolour Sketching Out-of-Doors* by Norman Wilkinson, Sir Isaac Pitman and Sons, Ltd., London, 1953.

*William Callow: An Autobiography* edited by H. M. Cundall, Adam and Charles Black, London, 1908.

# Index